LEGENDARY LOCALS

OF

HAVERHILL

MASSACHUSETTS

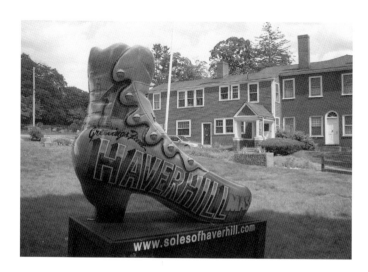

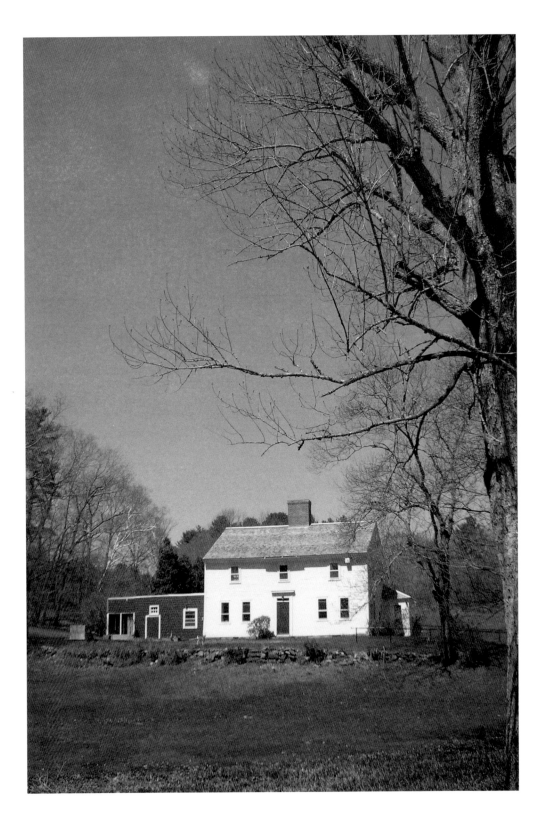

LEGENDARY LOCALS

OF

HAVERHILL
MASSACHUSETTS

CHRISTOPHER P. AND NANCY S. OBERT

LEGENDARY
LOCALS

This book is dedicated to those who have recorded and archived the history of Bradford and Haverhill throughout the centuries: J.D. Kingsbury, John B.D. Cogswell, George Wingate Chase, Patricia Trainor O'Malley, Charles W. Turner, John E. Hardy, and especially Barney Gallagher and Greg Laing. Without people like these, this book would not have been possible.

Copyright © 2011 by Christopher P. and Nancy S. Obert
ISBN 978-1-4671-0000-7

Published by Legendary Locals, an imprint of Arcadia Publishing
Charleston, South Carolina

Printed in the United States of America

Library of Congress Control Number: 2011936429

For all general information, please contact Arcadia Publishing:
Telephone 843-853-2070
Fax 843-853-0044
E-mail sales@arcadiapublishing.com
For customer service and orders:
Toll-Free 1-888-313-2665

Visit us on the Internet at www.arcadiapublishing.com

On the Cover: FROM LEFT TO RIGHT:
(TOP ROW) Bob Montana, cartoonist Archie Comics (Courtesy of Haverhill Public Library Special Collection, page 45); Cora Chase, opera singer (Courtesy of Haverhill Public Library Special Collection, page 55); Dr. Frank Lahy, established the Lahy Clinic (Courtesy of Haverhill Public Library Special Collection, page 83); Hannah Dustin, historical figure (Courtesy of Haverhill Public Library Special Collection, page 13); Abigail Hasseltine, teacher (Courtesy of Haverhill Public Library Special Collection, page 95).
(MIDDLE ROW) John Greenleaf Whittier, poet and abolitionist (Courtesy of Haverhill Public Library Whittier Collection, page 20); Muriel Sanders Draper, celebrated hostess (Courtesy of Haverhill Public Library Special Collection, page 25); Christopher Golden, author (Courtesy of Mr. Golden, page 39); Harold Livingston, TV and motion picture screenplay writer (Courtesy of Haverhill Public Library Special Collection, pages 32–33); John Katsaros, World War II veteran (Courtesy of Mr. Katsaros, page 123).
(BOTTOM ROW) Gladys Emerson Cook, artist (Courtesy of Haverhill Public Library Special Collection, page 44); Frank Fontaine, TV celebrity (Courtesy of Bruce Merrill, page 57); Donald J. Atwood, businessman and Deputy Secretary of Defense (Courtesy of Haverhill Public Library Special Collection, page 87); Tom Bergeron, TV celebrity (Courtesy of Mr. Bergeron, page 68); Israel Levitan, artist and sculptor (Courtesy of Alicia Armstrong Gallery, pages 46–47).

Page 1: In 2009 Haverhill celebrated Soles of Haverhill "Shoe-La-Bration" in recognition of the city's long history with the shoe industry. Artists created many oversized shoes to display throughout the city. This one is on the grounds of Buttonwoods Museum, home of the Haverhill Historical Society. (Image courtesy of PTP.)

Page 2: The Whittier homestead, 305 Whittier Road, is the birthplace of Haverhill's famous Quaker poet John Greenleaf Whittier. Whittier was born here on December 17, 1807. The house and grounds are open to the public. (Image courtesy of PTP.)

CONTENTS

Acknowledgments 6

Introduction 7

CHAPTER ONE History 9

CHAPTER TWO Literature 27

CHAPTER THREE Art 41

CHAPTER FOUR Sports & Entertainment 51

CHAPTER FIVE Business 71

CHAPTER SIX Public Service 93

CHAPTER SEVEN Military Service 111

Bibliography 126

Index 127

ACKNOWLEDGMENTS

First and foremost we would like to thank the staff of the Haverhill Public Library, particularly those that work in the library's Special Collections and the Whittier Collection. We would also like to thank the following people and organizations:

Tiffany Frary
Jan Williams
John E. Hardy & bradfordburialground.com
Pear Tree Publishing
Nabu Press
Wikimedia Commons
Marcelle Greenbaum
Anne L. More
University of Massachusetts, Amherst
Anthony S. & FindaGrave.com
Dean Zanello
Harold Livingston
Patricia Trainor O'Malley
John McIlveen
David Crouse
Christopher Golden
Marion Ettlinger
Alison Cagle
Andre Dubus III
Richard Smyth
Alicia Armstrong Gallery
Mark Hayden
Rick Leonardi
Mike Gould
Stephan LaPierre
United States Library of Congress
Bruce Merrill
Diane & Peter Breck
Billy Fellows
Brian Babineau & the Boston Red Sox
United States Olympic Committee
Dartmouth College
Alejandra
Tom Bergeron
Kevin Paul Hayes
Jon Shain
Sarah Martin

John Katsaros
Ginny Hamel Heffernan
The Collection *Boston Globe*/Getty Images
Arthur J. Migliori & Boris Migliori
Ken Smith & Pentucket Bank
Wes Pettengill
Michael J. Blinn
Effie Katsaros
United States Congress
Donald K. Laing
Willa Bellamy
History Division US Marine Corps
Dennis Deel & the Arlington National Cemetery
 Website
Charles R. Hinman, Director of Education and
 Outreach, USS *Bowfin* Submarine Museum &
 parkoneternalpatrol.com
Greg Moutafis
Margaret Toomey
Edward Ray & Andrew Ray
Angela Alberti
Phil Brown
Spider One
Melanie Higgins
Harriet Duffy
Barron Tenney
First Church of Christ
Art Lynch
Kristin Ranger & Pam Greenwalt
Valerie Yaros
Linda Koutoulas
Mike LaBella
Tim Coco
Mark E. Gilford
Barney Gallagher
Greg Laing
The Mayors of Haverhill

INTRODUCTION

More dear, as years on years advance,
We prize the old inheritance,
And feel, as far and wide we roam,
That all we seek we leave at home.
John Greenleaf Whittier

When we were asked to write a book about Haverhill for Arcadia Publishing, we were extremely excited and flattered. *Legendary Locals of Haverhill* is the first book in a series that highlights the people who are the heart and soul of America.

We knew that Haverhill, and its annexed sister Bradford, had a long and interesting history, but we weren't sure where to begin. So we went to the most logical source, the Special Collections department at the Haverhill Public Library. We started with the Haverhill Citizens Hall of Fame and then began digging deeper to find all the famous people who had been born here, or spent a significant part of their lives here. We were amazed to find so many interesting individuals with Haverhill ties. These citizens contributed their talents to fields such as art, literature, sports and entertainment, public service, and the military. We knew that we could never cover every one of these talented people, but we did endeavor to pick a sampling that would show what a diverse group of citizens this city has produced. We also included some of the monuments around town that honor groups of Haverhill's citizens: teachers, firefighters, police officers, and soldiers who have devoted their lives to the city (see Chapters Six and Seven). We hope readers learn a little bit more about the people of Haverhill and appreciate all of the contributions its residents have made, both locally and internationally. But before we begin our journey, let us start with a short history lesson about the original Haverhill inhabitants, the Native Americans.

No one knows exactly when these first people came and settled this land that today we call Haverhill. But they did come, and they lived their lives tied to the land. Like all human beings they hoped for a successful life, free of hardships and pain. They lived here for many centuries, each generation facing the trials of their time and working for the future. There were times of peace and times of war, times of feast and times of famine, and still they struggled on. At one time there were many Native American villages along the banks of the Merrimack River. "Merrimack" is a Native American word referring to the swift waters and strong current of the river, which was such a large part of their lives. At some unknown point the people of what is now called New England—including the Merrimack Valley— first had contact with the people of Europe. Most of these contacts did not work out well for the Native Americans, for these foreigners, regardless of their intentions, brought with them sickness and disease.

In 1616, Hepatitis A spread like wildfire across the coastal region of New England, from southern Maine to Narragansett Bay, probably spread by contaminated food. It took approximately three years for the disease to run its course, and when it was finished 90 percent of the coastal Native Americans were dead. In 1633 smallpox hit the area. Because smallpox has a 12-day incubation period, many Native Americans unknowingly passed the disease far and wide. It is believed that this second deadly wave of sickness killed one-third to one-half of the remaining New England Native American population. By the time the first European settlers landed on the coast and worked their way up the Merrimack,

the plagues had already decimated the local population. Records show that more than 50 of the first European settlements were located on the sites of Native American villages that had been wiped out by disease.

The area that we now call Haverhill was originally called Pentucket, which means "land of the winding river." The land was sparsely populated by Native Americans who were part of the Pennacook Confederacy. They spoke a combination of Abenaki and Algonquin languages. During the first few years of the 17th century, they were at war with the Micmac tribe due to trading pressures between the Native Americans and the encroaching Europeans. They lived in scattered villages along the Merrimack, with the largest of these, Pentucket, located near the mouth of Little River. They were a shy and fearful people because of the war and plagues that had hit them so harshly.

In 1640 Massachusetts governor John Winthrop granted Nathaniel Ward permission to create a new English settlement in Pentucket. The colonists were friendly with Chief Passaconnaway, leader of the Native Americans, and he did not interfere with the settlement. Twelve men—Job Clement, Daniel Ladd, Joseph Merrie, and Abraham Tyler from Ipswich, and James Davis, Samuel Gile, Christopher Hussey, Richard Littlehale, Henry Palmer, John Robinson, William White, and John Williams from Newbury—were the first settlers, landing near what is now the corner of Mill Street and Water Street. The first house and garden were located near there, as was the burial ground. These men were seeking religious freedom and the chance for a new life. They were a strong-willed and courageous group, skilled as farmers or tradesmen. They brought with them religion, technology, and law. In 1641 the Reverend John Ward, Nathaniel Ward's son, came to Pentucket. The men were so delighted to have a pastor that they renamed the town Haverhill, after the English town where John Ward had been born. On November 15, 1642, Chief Passaconnaway sent representatives Saggahew and Passaquo to meet with the Haverhill colonists. The colonists paid three pounds, ten shillings to buy the land, which was 14 miles long (eight miles west and six miles east of Little River) and six miles wide. This land area was much larger than the current city of Haverhill. Today that land would include Haverhill and parts of

Haverhill waterside c. 1910
Two scenes of the Merrimack River flowing through downtown Haverhill. (Images courtesy of Smith Brothers Printing, Library of Congress.)

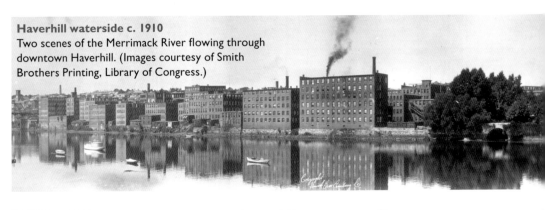

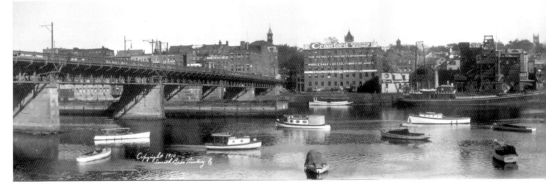

Methuen, in Massachusetts, and Atkinson, Hampstead, Plaistow, and part of Newton in New Hampshire.

To help us move us forward into the present, here is a little bit of background on some of Haverhill's first citizens. On December 25, 1644, Job Clement and his wife, Margaret Dummer, were the first persons to be married in Haverhill. Clement, the town's first tanner, set up his tan-house near Mill Brook. Over time more people moved to Haverhill. In 1645 Haverhill was incorporated into a town with the first selectmen being James Davis, Thomas Davis, Thomas Hale, Henry Palmer, and William White. The first church body was also assembled in 1645 with John Ward as pastor. In 1648 the people erected the first meeting house, and in 1660 the first public school was established with Thomas Wesse as its first instructor. In 1662 the first militia was created, with Daniel Ladd as its lieutenant and William White as its captain. During its first four decades, the people of Haverhill had few problems with the Native Americans, but tensions were beginning to be felt all over New England. The pressures of the ever-expanding English presence and the diminishing natural resources created a fear in the Native Americans that was soon to boil over. The latter half of the 17th century and the early part of the 18th century saw armed conflicts break out between the white citizens of Haverhill and the Native Americans. Many were killed on both sides, and Haverhill history books record the names of those citizens killed or taken prisoner. The famous Hannah Dustin and her nurse Mary Neff were taken prisoner in March 1697. Hannah, with the help of a young boy, killed their captors and managed to escape. The Rev. Benjamin Rolfe, his wife, and child were not so lucky and were killed during a raid in Haverhill in 1708. Many other Haverhill citizens were killed or captured, but by the second decade of the 18th century the Native Americans were no longer a threat. War and disease had essentially wiped them from the map.

After the Native American danger passed, events happened very quickly in Haverhill. The population started to grow, and with it came a larger mix of cultures. This mixing led the way for a new and exciting vision for the future of Haverhill. The footprint of the city changed as the population increased, which amplified the number of streets and houses, schools, and businesses. Roads were paved and bridges

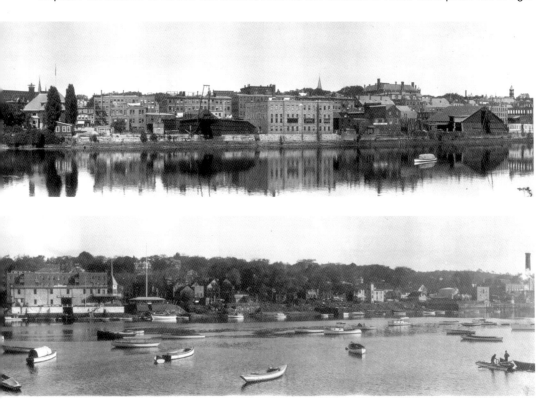

were built to improve the city's circulation. Industry also came to Haverhill (see Chapter Five). Haverhill had many products that were in high demand, such as hats, textiles, and leather goods. But the greatest industry was the shoe business, which made Haverhill famous. Haverhill became known as the "Queen Slipper City." Because of the growth of the population (over 10,000 people in 1870) and its booming industry, Haverhill was incorporated into a city in November 1870. The city leaders changed to a new form of government to accommodate the growing city. With this new government came new city projects and improvements, which brought in turn more people and more industries. With the future of Haverhill looking so bright, the neighboring town of Bradford (located on the southern side of the Merrimack River across from Haverhill) considered joining Haverhill to make one large city.

Bradford and Haverhill had a long shared history, and Bradford had considered a merger a few times before but never had the necessary votes. Bradford was first settled in 1649 as part of Rowley. In 1672 it was renamed Bradford after Bradford, England. In 1726 the east parish of Bradford was established but separated in 1850 and became the town of Groveland. In 1896 the people of Bradford voted again for annexation. There were good reasons for both town and city to join, and this time they had the votes. Bradford was annexed to the city of Haverhill in 1897. Bradford, now an official part of Haverhill, still retained its own identity. Although many of the streets in Bradford had to have the word "South" added in front (because Haverhill also had streets with the same names), today mail will still be delivered to its homes regardless of how the letter is addressed, Bradford, Massachusetts, or Haverhill, Massachusetts. It has been over 100 years since Bradford and Haverhill merged, but each still retains some of its independence. In this book we were sure to include some of the past citizens of Bradford, even though in their lifetime they were not Haverhill citizens: people like Robert Mullicken Sr., Nathaniel Thurston, and John D. Kingsbury. While working on the book, we moved into the present and included present-day Bradford citizens such as John M. McIlveen, Richard Smyth, and Christopher Golden, and businesses such as Carter's Ice Cream, Arthur Sharp Hardware, and Kimball Tavern Antiques.

Many people, from both sides of the river, helped us to compile the information and photos for this book, and for this we are extremely grateful. We thoroughly enjoyed digging into Haverhill's past (and present) and discovering the gems this city had to offer future generations. We know that there are many other names of legendary citizens that could have been included, and we recognize that most of the history of Haverhill's Native Americans is lost. But perhaps more Haverhill residents can be covered in another volume. We hope reading about the individuals we were able to cover encourages today's citizens of Haverhill and Bradford to find more of these incredible people on their own.

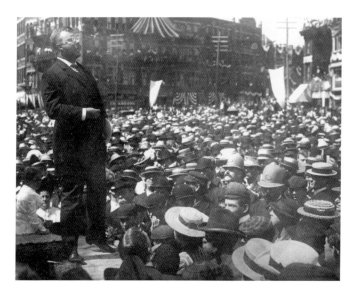

President Roosevelt in Haverhill, 1902
Pres. Theodore Roosevelt gives his famous US Navy speech "In battle the only shots that count are those that hit." (Image courtesy of George Grantham Bain Collection, Library of Congress.)

CHAPTER ONE

History

Out of monuments, names, words,
proverbs, traditions, private records and
evidences, fragments of stories, passages
of books, and the like, we do save and
recover somewhat from the deluge of time.
Francis Bacon

The history of Haverhill mirrors that of America. It is a patchwork quilt of different people and diverse cultures. It has its roots extending back to the Native Americans, it changed landscape with the pioneers, and it has flowed forward through waves of immigrants. The citizens of Haverhill have been store clerks and farmers, artists and bankers, doctors and soldiers. Many of Haverhill's citizens have made a huge impact on the city. It is difficult to imagine Haverhill without John Greenleaf Whittier, since streets, businesses, and schools are named in his honor. Hannah Dustin is another example of a resident who has made her mark on the psyche of Haverhill. Some citizens are simply remembered because of the number of wives they have had. We know these stories because of people like G.W. Chase and J.D. Kingsbury, who recorded this history and forever locked it into words for future generations to read. Some citizens are less well known but still played their part in the building of Haverhill. It does not matter if the person was a gravestone carver, a schoolchild, a teacher, or a judge. Each added to the tapestry that is the city of Haverhill.

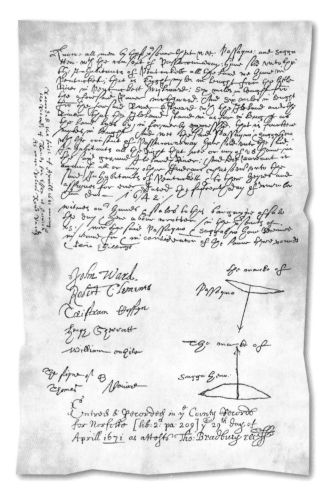

Purchase of Pentucket Deed

Native Americans originally called the Haverhill area "Pentucket," which means "land of the winding river." The Indians lived mainly along the Little River, and over the years many artifacts were found there, at other locations in town, and along the Merrimack River. In 1640 12 white settlers came to the area and two years later 3 pounds, 10 shillings purchased the land from the Pentucket Indians, a band of the Pennacook tribe led by Chief Passaconnaway. According to historical records, including the Haverhill Deed of Township, the deed was signed on November 15, 1642, by six settlers and two Indians. The signers were John Ward, the first minister in Haverhill; Robert Clements, the owner of Haverhill's first gristmill and the first deputy to the General Court; Tristam Coffyn, the first person in Haverhill to use a plow; Hugh Sherratt, who owned a tavern on the west side of Little River; William White, the leader of the group and keeper of the deed; Thomas Davis, who was a sawyer (someone who makes his living sawing wood); and two Indian shamans named Passaquo and Saggahew. Passaquo and Saggahew were there to represent Chief Passaconnaway and signed the deed with two "bow and arrow marks." Some believe the deed was signed under the large oak tree located on the grounds of the Historical Society, while others believe the deed was written and signed at the home of William White on Mill Street. Even though the deed was signed in 1642, it was not entered into the county records until April 29, 1671. The deed and Native American artifacts are in the collection of the Haverhill Historical Society. (Image courtesy of HPLSC.)

Statue of Hannah Dustin, GAR Park

Dustin, sometimes spelled Duston (1657–1732), is one of Haverhill's most controversial figures. Was she a heroine or a savage? On March 15, 1697, Hannah's husband, Thomas Dustin, was working in the field with his children and saw Indians approaching. He sent his children to the closest garrison for safety and hurried to his home to warn his wife. The Indians set the house on fire and kidnapped Hannah along with her six-day-old baby and Mary Neff, the baby's nurse. During that same raid, 27 settlers were killed, nine houses were burned down, and 13 other people were captured by the Abenaki Indians. As the story goes, the Indians killed Hannah's baby and forced her and the small group to travel north for more than a month. They were brought to an island near Concord, New Hampshire, at the mouth of the Contoocook River. The Indians planned to bring the captives north to Canada, where they would be sold to the French. A young boy, Samuel Lennardson, had been captured in Worcester a year and a half before Hannah and was treated as family by the Indians. He taught Hannah how to kill and scalp someone. While the Abenaki were sleeping, Hannah and Samuel killed and scalped 10 Indians, and along with Neff they escaped and returned to Haverhill. They began their escape around April 30, 1697, and traveled down the Merrimack River in canoes, but returned shortly after to retrieve the scalps as evidence that they had killed the Indians. Upon returning to Haverhill, the group of captives then traveled to Boston to present the scalps, along with the tomahawk used in the scalpings, to the General Assembly. Here, Hannah had the honor of being interviewed by Cotton Mather. She was paid a bounty of 50 pounds for the scalps. She later became the first woman in the United States to have a statue erected in her honor. The original monument to Dustin is in Barre, Massachusetts. A second statue stands in GAR Park in Haverhill. Referred to regularly in this book, GAR Park commemorates soldiers who lost their lives in wars. It is named after the fraternal organization of Union Army veterans—the Grand Army of the Republic. (Image courtesy of HPLSC.)

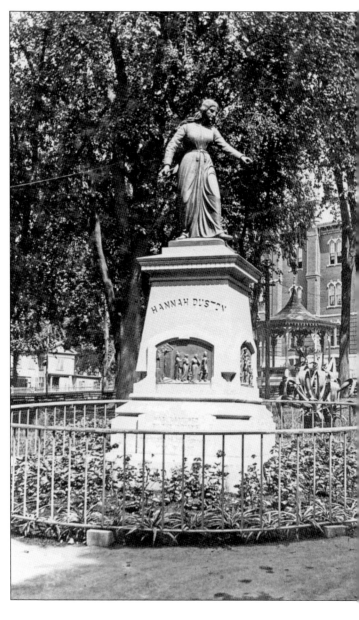

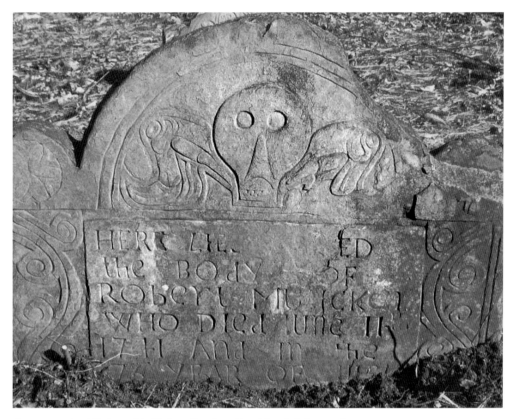

Gravestone of Robert Mullicken Sr., Bradford Burial Ground
Mullicken (1668–1741) was originally a weaver, but it is believed he learned gravestone carving from John Hartshorne, the prominent local carver, while he was in his mid-40s. Mullicken's first gravestones appeared in 1714. He created stars and stylized fleur-de-lis as common designs, using skulls and wings on only two stones, both for captains. Mullicken's gravesite in the Bradford Burial Ground includes a gravestone carved by his sons. (Image courtesy of John E. Hardy and BradfordBurialGround.com.)

Bailey Bartlett
Born in Haverhill and educated in Haverhill public schools, Bartlett (1750–1830) was a local merchant until serving as a member of the Massachusetts House of Representatives from 1781 to 1784, and again in 1788. He was a member of the convention that adopted the US Constitution in 1788. Bartlett held numerous other government posts from 1789 until his death, including becoming high sheriff of Essex County, a member of the Massachusetts Senate, a US congressman, and treasurer of Essex County. He is buried in Pentucket Cemetery in Haverhill. (Image courtesy of HPLSC.)

Ghost of Kimball Tavern, Salem Street
The Kimball Tavern was built in 1692 by Benjamin Kimball and served as a home for seven generations of the Kimball family. The building has been modified many times and has served as a meeting place, tavern, and recently an antiques shop. In 1803 the idea of the Bradford Academy was conceived here. With all of this history happening in one location, it is not unusual to hear of ghost stories associated with the building. Over the years strange sounds and lights have been heard and seen, including the shadow of a dog, the sound of a little girl, and strange footsteps. (Image courtesy of PTP.)

Benjamin Rolfe Memorial, Haverhill City Hall
Rolfe (?–1708), a pastor in Haverhill, was a victim of the vicious Indian attack of 1708. His home was being guarded by three soldiers when the Indians attacked. Rolfe was awakened by the Indians' yelps and called for the guards for help, but they were too frightened to be of any assistance. Rolfe was wounded in the arm while trying in vain to hold the door shut. He then tried to escape out the back door toward the well, but the Indians caught and killed him. His wife, infant child, and the three soldiers were also killed in the attack, although two of his children were saved by a slave. There is a memorial to this event near the site where it occurred in front of city hall at the corner of Main and Summer Streets. (Image courtesy of PTP.)

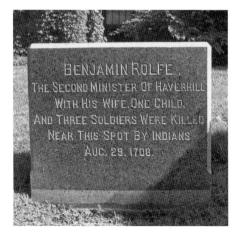

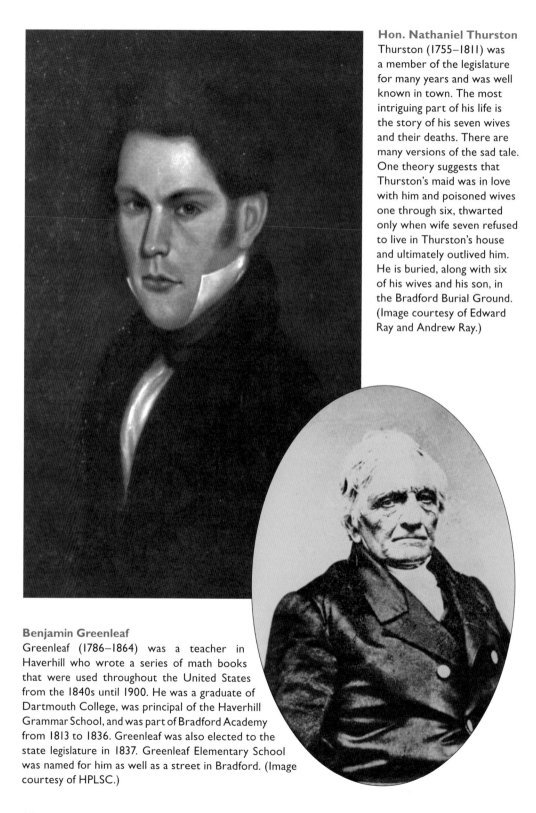

Hon. Nathaniel Thurston Thurston (1755–1811) was a member of the legislature for many years and was well known in town. The most intriguing part of his life is the story of his seven wives and their deaths. There are many versions of the sad tale. One theory suggests that Thurston's maid was in love with him and poisoned wives one through six, thwarted only when wife seven refused to live in Thurston's house and ultimately outlived him. He is buried, along with six of his wives and his son, in the Bradford Burial Ground. (Image courtesy of Edward Ray and Andrew Ray.)

Benjamin Greenleaf Greenleaf (1786–1864) was a teacher in Haverhill who wrote a series of math books that were used throughout the United States from the 1840s until 1900. He was a graduate of Dartmouth College, was principal of the Haverhill Grammar School, and was part of Bradford Academy from 1813 to 1836. Greenleaf was also elected to the state legislature in 1837. Greenleaf Elementary School was named for him as well as a street in Bradford. (Image courtesy of HPLSC.)

Harriet Atwood Newell

Newell (1793–1812) was born in Haverhill and was extremely interested in religion and religious readings at an early age. When she was 11 years old, she began keeping a diary of "moral reflections." At the age of 12, while attending Bradford Academy, she organized a society for praying and discussing religion. She later became one of the first Christian missionaries from the United States to travel abroad. In 1810, at the age of 17, she married the Reverend Samuel Newell, and along with their friends Ann and Adoniram Judson, they traveled to India and Burma to preach the word of God. Unfortunately, Harriet and Samuel were ordered to leave Burma by the government. They went on to the Isle of France, and after suffering the death of her premature baby, it was here that Harriet died in November of 1812, at the tender age of 19. On the marble monument above her grave there is an inscription, which reads in part, "Her name lives, and in all Christian lands is pleading with irresistible eloquence for the heathen. This humble monument to her memory is erected by the American Board of Commissioners for Foreign Missions." (Image courtesy of First Church of Christ.)

James Varnum Smiley
Born in Haverhill, Smiley (1820–1883) was very studious as a young boy. He did so well in his classes that the regular public school was not enough for him, and he went to Pembroke Academy in New Hampshire for a better education instead. After completing his education, he returned to Haverhill to become a teacher at the Centre Grammar School, a position he remained in for more than 12 years. He later became the postmaster, before going into business with A.B. Jaques to open a very successful bookstore. He held many positions in the community, including assessor, president of the Haverhill Gas Company, and trustee of the Haverhill Savings Bank. Smiley was elected mayor in 1873 and served for two terms. The Smiley School was later named for him. (Image courtesy of HPLSC.)

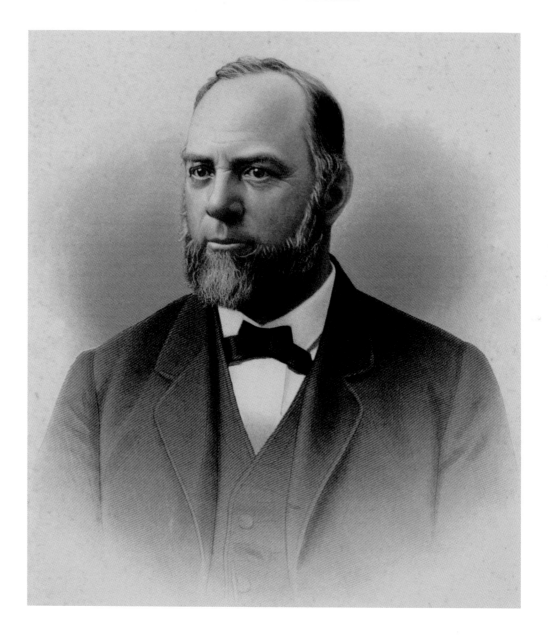

Edwin Bowley
Bowley (1822–1884) was born to a very poor Haverhill family. Because of this he was sent to live and work on a farm on Washington Street with a man named Varnum Ayer. As an adult he bought the farm and made it a very lucrative business. He later started working at a grocery store on Water Street, becoming a partner with another businessman and forming E. Bowley & Co., a very well-known business on Merrimack Street. Bowley became very successful in real estate and owned 78 pieces of land when he died. In 1882 he was nominated for the State Senate and served in that position until his death. While in the Senate he served on many committees, including Fisheries, Roads and Bridges, and Woman's Suffrage. He was so well respected in the city that on the day he died the grocers closed their stores and the flag at the fire station was flown at half mast. (Image courtesy of HPLSC.)

John Greenleaf Whittier

Whittier (1807–1892) was born in Haverhill to Quaker parents in a farmhouse that is still standing, preserved and open to the public. He was known for both his poetry and his opposition to slavery. Whittier enrolled in the Bradford Academy in 1827 and worked as a shoemaker and a teacher to pay for his education. By this time he was already well known for his poetry and wrote an ode for the dedication of the Academy. He attended the Academy for two years and then became the editor of the *American Manufacturer*, a Boston weekly. He edited the *Essex Gazette* for a short time in 1830 and was involved in local politics as well. He was also the editor of the *Haverhill Gazette* for a time and contributed numerous writings to the newspaper. Whittier was elected to the Massachusetts Legislature in 1835. In 1836 Whittier became editor of the *Gazette* again before selling his farm and moving to Amesbury, Massachusetts. Whittier's literary career included the publication of *The Legends of New England* in 1831, *Justice and Expediency* in 1833, and his signing of the Anti-slavery Declaration in Philadelphia. In 1840 he helped form the Liberty Party, which later merged into the Free Soil Movement. He was an important asset of John Quincy Adams in his fight against limitations on free speech or press. He later became the editor of both the *Pennsylvania Freeman* in Philadelphia and the *Middlesex Standard* in Lowell, both anti-slavery publications. His poems at this time became powerful propaganda to be used in awakening the consciences of the North. During the Civil War, Whittier's poems gained widespread acclaim with even Abraham Lincoln noting that Whittier's poetry was what the soldiers needed to hear. With the founding of the *Atlantic Monthly* in 1857, Whittier gained major recognition for his poetry, as well as becoming closer to writers such as Ralph Waldo Emerson and Oliver Wendell Holmes. The poem "Snowbound," which was published

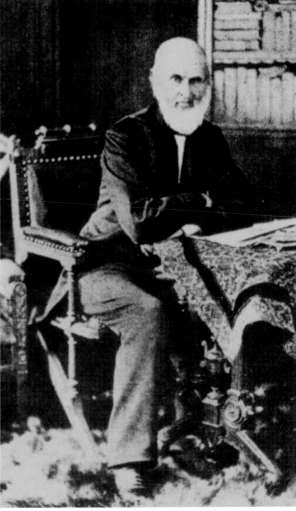

in 1866, brought both national and literary fame to Whittier and earned him the nickname "the people's poet." The poem is still read and reenacted in front of the hearth in his homestead every year. His last visit to his birthplace was in late October 1882. In 1888 his collected works were so numerous that they filled seven volumes. He lived in Amesbury, Massachusetts, from 1836 to 1876, and then moved to Danvers, Massachusetts, for a while, spending summers in the mountains of New Hampshire. In 1892, when Whittier's health was failing, he wrote his last work, a tribute to Oliver Wendell Holmes. He died on September 7, 1892, in Hampton Falls, New Hampshire. (Image courtesy of Haverhill Public Library Whittier Collection.)

Gravestone of Lydia Ayer, Walnut Cemetery

Ayer (1813–1827) was John Greenleaf Whittier's classmate and childhood sweetheart and is referred to in his poem "In School Days." They both attended a one-room schoolhouse near their homes. Haverhill schoolchildren still make visits to her grave in Walnut Cemetery to recite the famous poem, many dressed in period clothing. Admirers of Whittier have marked Lydia's grave with a stone showing the little school. Lydia died at the very age of 14. (Image courtesy of PTP.)

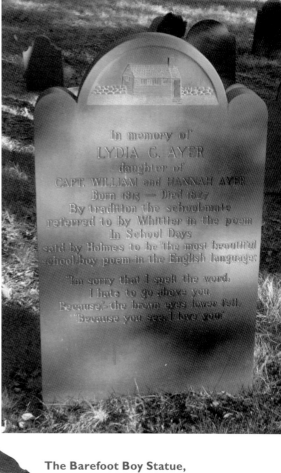

The Barefoot Boy Statue, Haverhill Public Library

"The Barefoot Boy" is John Greenleaf Whittier's most famous fictional character. Artist Tita Hupp of California created a statue of the barefoot boy that was given by Leewood and Irene Carter as a memorial to the Haverhill High School class of 1939. It was dedicated in 1995 at a ceremony in the Haverhill Public Library. The boy sits on a rock with a stick in his outstretched hand, surrounded by a pool of water that children eagerly throw pennies in. (Image courtesy of PTP.)

The History of Haverhill, Massachusetts by George Wingate Chase
George Chase (1826–1867) was born in Haverhill but left at the age of 19 "to seek his livelihood." He had many professions, including book agent, newspaper agent, and early photographer. He later learned shoemaking, opening a shoe manufacturing mill in Haverhill with his brother in 1857. He was also a librarian for the Haverhill Library Association and was elected to the State Legislature in 1860. Chase is most famous for his book *The History of Haverhill, Massachusetts*, which was published in 1861 and traces Haverhill's history from a 17th-century port city to an 1860s industrial booming town. He is buried in the family plot in Linwood Cemetery in Haverhill. (Image courtesy of PTP.)

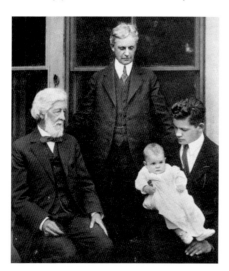

The Chase Family, c. 1910
Stuart Chase (1888–1985), seated with his son Robert, was raised in Haverhill, becoming a third-generation CPA. He attended both MIT and Harvard before joining his father's firm, where he became a partner. He was a member of the Federal Trade Commission (1917) and the Food Administration (1918) and also published 33 books dealing with industrial waste, trade associations, economics, and natural resources. Many believe Chase coined the phrase "New Deal," made famous by Franklin Delano Roosevelt in 1932. The photograph shows Robert Stuart Chase (Uncle Stuart), Harvey Stuart Chase (father), and Stuart Duane Chase, holding Robert Stuart Chase. (Image courtesy of HPLSC.)

Ira A. Abbott

Abbott (1845–1921) was born in Vermont but lived in Haverhill during two periods in his life, from 1872 to 1904 and again from 1912 to 1921. He served in the Civil War with the 9th Vermont Regiment from 1864 until the war's end. He graduated from Dartmouth in 1870 with honors and then became a teacher at Phillips Academy in Andover, Massachusetts, while studying law under a local attorney. He was admitted to the bar of Essex County in 1872. Abbott worked in a Haverhill law office in 1871, was city solicitor from 1873 to 1874, was appointed special justice of the police court in 1877, which then became the Central District Court of Northern Essex, served two different terms as a member of the school committee, and was secretary of the Haverhill civil service examiners. He then formed the law offices of Abbott and Pearl with Francis H. Pearl, Esq., in 1877. His partnership with Pearl, one of the best-known law firms in Haverhill, lasted 21 years until his appointment as a judge to the local district court. In 1904, Judge Abbott was appointed by President Theodore Roosevelt to the New Mexico Supreme Court, an appointment that was highly endorsed by Attorney General William H. Moody. Prior to this position, Judge Abbott had been appointed to the district court by Governor Walcott in 1898. He held the Supreme Court position for seven years. According to a leading journal in New Mexico, Judge Abbott's work "demonstrated in a striking manner how close the judiciary is to the moral foundation of a community." At one point Judge Abbott was also offered a place on the bench in China, a position he declined. During his life in Haverhill, he was the trustee of several local banks and was one of the founders of the Haverhill and Groveland Street Railway Co., working his way up to president. He was also president of the Haverhill Historical Society, a director of the Second National Bank, a trustee of the Haverhill Savings Bank, and a member of the Pentucket Club, the Monday Evening club, and the Major How Post 47. He generously contributed $1,000 in 1898 to start a fund to pay for the Hale Hospital patients' care. He returned to Haverhill in 1912, but did not resume his law practice. He is buried in Linwood Cemetery. (Image courtesy of HPLSC.)

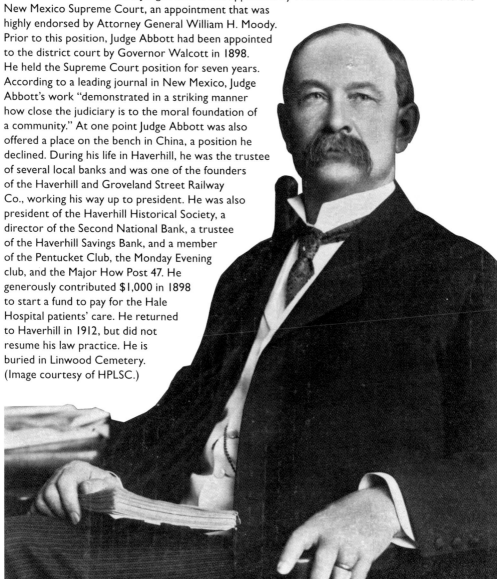

Dr. Duncan MacDougall
A Haverhill surgeon (1866–1920), MacDougall studied dying patients from 1907 to 1911, trying to prove the existence of a human soul by weighing the patient before, and right after, death. He found the average loss of mass to be about 21 grams (this measurement inspired a movie in 2003). His results were published in the *New York Times* and the medical journal *American Medicine*, but there was no scientific merit attributed to his work. (Image courtesy of HPLSC.)

John D. Kingsbury
Kingsbury (1831–1908) was a pastor at the First Church of Christ, adjacent to the Bradford Common. He began his pastorate on January 11, 1866, and remained there for 35 years. During his tenure many important improvements were made, including the building of the Bradford Chapel, the formation of the Ward Hill Church, and an increase in the size of the congregation. In 1882, the 200th anniversary of the church was observed and Pastor Kingsbury wrote the *Memorial History of Bradford*. The observance of his 25th anniversary as pastor in 1891 was a noteworthy event in the area. In 1900 he left to do missionary work in Idaho, Arizona, Utah, New Mexico, and Oklahoma. (Image courtesy of First Church of Christ.)

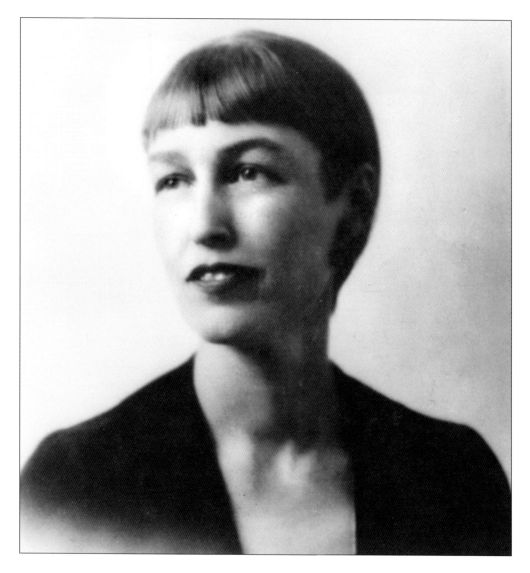

Muriel Sanders Draper

Draper (1887–1952) was born in Haverhill, the daughter of Thomas Sanders, the man who financed Alexander Graham Bell's telephone. She grew up at Birchbrow, the family mansion located near Plug Pond, and attended local schools. She went on to marry Paul Draper in 1909 and moved to Italy, and later London. The Draper home in London at 19A Edith Grove was a regular gathering spot for many famous musicians of the time. Many of the parties lasted all night, with Muriel serving raspberries and champagne to the guests for breakfast. After the marriage ended around 1916, she moved to New York City, where she was known for her elaborate New Year's Eve parties. Mrs. Draper was one of the most well-known hostesses in the world of music, art, and literature. She also went to Moscow in 1946 to attend the National Council of American-Soviet Friendship, becoming chairman of the Council's Committee of Women. She was invited to give a talk at Haverhill High School by the Haverhill Girls Club in 1929, where she thanked her hometown for "a rich and thrilling life." She was the mother of Paul Draper, a famous dancer, and Saunders Draper, an actor. She died in 1952 in New York. (Image courtesy of HPLSC.)

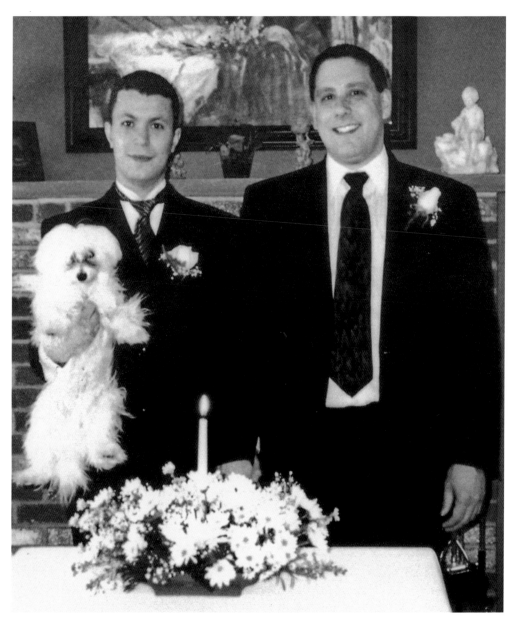

Genesio Oliveira and Tim Coco
Coco (1961–present) is the president and chief executive officer of COCO+CO, an advertising and marketing firm located in Ward Hill. Tim (at right) and his partner, Genesio "Junior" Oliveira, were married legally in Massachusetts on March 3, 2005, but were separated for three years due to the federal Defense of Marriage Act (DOMA), which did not recognize gay marriages. Junior lived in his home country of Brazil while awaiting a legal decision from the government, while Tim continued to challenge this decision in Haverhill. With the aid of Sen John Kerry, they were the first gay couple to successfully challenge DOMA and were reunited in 2010. Their unusual campaign, involving both public relations and legal tactics, became the model for others fighting similar discrimination. (Image courtesy of Tim Coco.)

CHAPTER TWO

Literature

Any man who will look into his heart
and honestly write what he sees there,
will find plenty of readers.
Ed Howe

Haverhill's literary tradition dates back to its early founders, who kept diaries and wrote letters about their experiences. Today Haverhill has connections to young adult literature, as well as the fantasy and horror genre, with authors such as Bellairs, Golden, McIlveen, and Goudsward. Even H.P. Lovecraft spent time here in Haverhill, purportedly working on some of his stories while in town. The famous father and son authors Andre Dubus and Andre Dubus III at one time called Haverhill home, as did screenwriter Harold Livingston, who went on to write for many prominent television shows. Let us not forget Haverhill's most well-known literary great, John Greenleaf Whittier, who made such an impact on Haverhill he needed to be listed in the Historical chapter. (Historian authors G.W. Chase and J.D. Kingsbury are also mentioned in the Historical chapter, as well as mathematics author Benjamin Greenleaf.) Haverhill has probably given its largest literary contribution to the field of poetry, with Whittier and the likes of Fitts, Smythe, and Scott. Modern day Haverhill poets Emiro and Smyth, in addition to poetry groups such as the Greater Haverhill Poets, are still probing the depths of our emotions, trying to understand the world and put it into words.

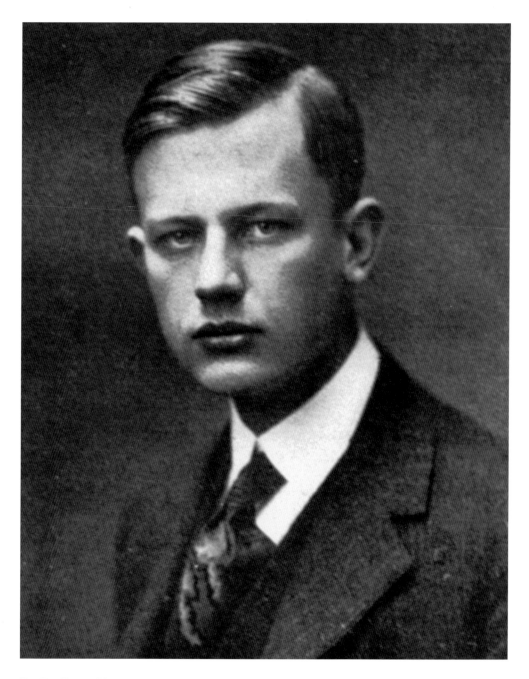

Dudley Eaton Fitts
Fitts (1903–1968) was born in Boston and moved to Haverhill as a young boy, living there from 1911 to 1921. He was a 1921 graduate of Haverhill High School and a 1926 graduate of Harvard. He taught at both the Choate School in Connecticut and Phillips Academy in Andover, Massachusetts. His poetry has appeared in many magazines, and he was awarded the Golden Rose of the New England Poetry Society. Fitts was well known for his translations of Greek and Latin literature. He died in Lawrence, Massachusetts. (Image courtesy of HPLSC.)

The Origin of Consciousness by Charles Augustus Strong
Strong (1862–1940) was born in Haverhill and attended Phillips Exeter Academy, studying Latin and Greek. He later attended the University of Rochester and Harvard University, where he cofounded the Harvard Philosophical Club. He taught at Clark University, the University of Chicago, and Columbia University. His many writings include *The Origin of Consciousness* (1918), *Essays in Critical Realism* (1920), and *A Theory of Knowledge* (1923). Strong died in Italy, and his villa there was left to Georgetown University by his daughter. (Image courtesy of Nabu Press.)

Daniel Webster Smythe
Smythe (1908–1981) graduated from Haverhill High School in 1927 before going on to serve in the US Army during World War II. He later earned degrees in American literature from Union College and the University of Pennsylvania. Early in his life he worked on a farm and a wildlife sanctuary, which is why many of his poems deal with nature. Smythe was friends for many years with Robert Frost and wrote about this relationship in his famous book *Robert Frost Speaks*. (Image courtesy of HPLSC.)

John A. Bellairs
Born in Michigan, Bellairs (1938–1991) attended University of Notre Dame and the University of Chicago and taught English at several New England colleges. He was an author of mostly fantasy and gothic mystery for young adults, with one of his most famous works being *The House with a Clock in Its Walls*. While living in Haverhill, Bellairs was a frequent visitor to the Haverhill Public Library and local schools, encouraging children to read and write. He died in Haverhill, leaving behind two unfinished manuscripts, which his estate commissioned author Brad Strickland to complete. (Image courtesy of HPLSC.)

James Underwood Crockett
Crockett (1915–1979) was a 1933 graduate of Haverhill High School, a past director of the American Horticultural Society, and the author of 15 books on gardening. His gardening career began at the Gray and Cole Nursery in Ward Hill, and he later studied horticulture at both the Stockbridge School of Agriculture and at Texas A&M University. He was the first host of the television show *Crockett's Victory Garden* on Boston's PBS Channel 2 in 1975, the oldest gardening TV show in the United States. The garden used on the TV show was located right outside the studios at WGBH in Allston, Massachusetts. His written works include volumes in the *Time-Life Encyclopedia of Gardening* and three books based on the TV series: *Crockett's Victory Garden, Crockett's Indoor Garden,* and *Crockett's Flower Garden.* His guides to gardening are unusual because they are organized by the annual calendar detailing tasks month by month, not by the plants in the garden, as most other books are laid out. Crockett is buried in Sleepy Hollow Cemetery in Concord, Massachusetts. (Image courtesy of University of Massachusetts, Amherst.)

Winfield Townley Scott
Scott (1910–1968) was born in Haverhill, graduating from Haverhill High School in 1927 and Brown University in 1931. He was a poet, a critic, and a diarist who also wrote essays on horror writer H.P. Lovecraft and was also the editor of the *Providence Journal and Evening Bulletin.* Scott was mostly known for his journals, which were published as *A Dirty Hand* (1958). He is buried in Santa Fe, New Mexico. (Image courtesy of Anthony S. and FindaGrave.com.)

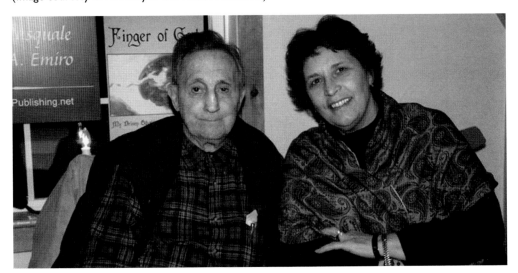

Pasquale Emiro and His Daughter Christine
"Pat" Emiro (1923–present) grew up in Somerville. He was a guidance counselor in the Amesbury and Haverhill school systems. Emiro has written two books, *Finger of God,* which is his life story, and *Expressions from His Heart,* a book of spiritual poems. He is a member of the Greater Haverhill Poets. Today Emiro is a hospice volunteer, a member of the Friendly Persuasion Toastmaster's Club, and a member of many church groups. (Image courtesy of Dean Zanello.)

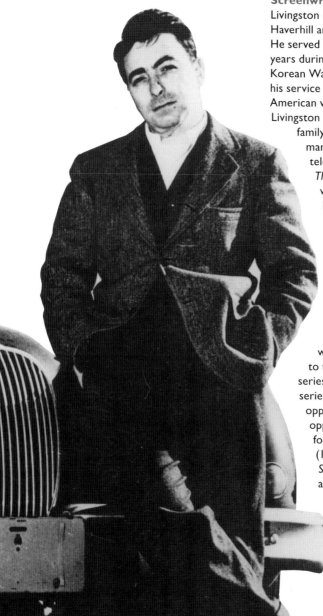

Harold Livingston, Hollywood Screenwriter

Livingston (1924–present) was born in Haverhill and attended Brandeis University. He served in the US Air Force for three years during World War II and also in the Korean War from 1950 to 1951. Between his service dates he was one of the original American volunteers in the Israeli Air Force. Livingston moved to Los Angeles with his family in 1960, and he has written many novels, screenplays, and television episodes. His first novel, *The Coasts of the Earth* (1954), won a Houghton Mifflin Literary Fellowship Award. Among Livingston's television series work are episodes for *Mission: Impossible* (1970–1972), *Mannix* (1974), *Banacek* (1974), *The Six Million Dollar Man* (1974), *Archer* (1975), and *Fantasy Island* (1978). He also worked on the never-developed TV series *Star Trek: Phase II*, which would have been the first sequel to the original *Star Trek* television series. While working on the television series *Star Trek: Phase II* (see image opposite), Livingston was offered the opportunity to write the screenplay for *Star Trek: The Motion Picture* (1979). After the huge success of *Star Wars*, Livingston was asked to adapt a story by Alan Dean Foster into a *Star Trek* movie, which the studio hoped would lead to the same type of success. The woman with her hands over her head is Majel Barrett Roddenberry, the wife of *Star Trek* creator Gene Roddenberry. She played Number One on the *Star Trek* pilot, Nurse Chapel on the original *Star Trek* TV series, Lwaxana Troi on *Star Trek: The Next Generation*, and was the voice of the computer on many episodes. (Images courtesy of Harold Livingston and HPLSC.)

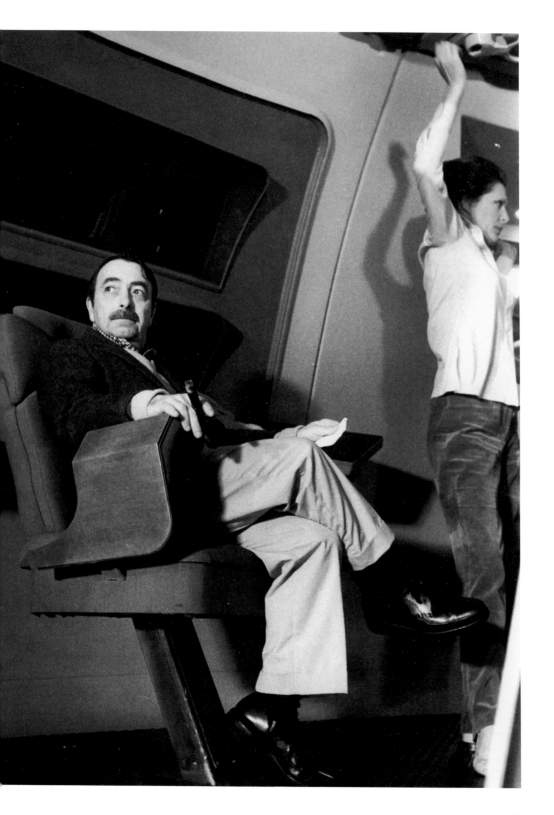

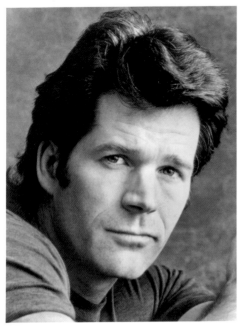

Andre Dubus II (TOP LEFT)
Andre Dubus II (1937–1999) was born in Louisiana and educated by the Christian Brothers, an order that stressed literature and writing. He served in the Marine Corps, married, and had a family before moving to Haverhill. Here he taught at Bradford College and wrote many essays and short stories. In 1986 Dubus was hit by a car while helping at an accident scene and was confined to a wheelchair for the rest of his life. He continued to write while also holding writers' workshops in his home. Dubus is buried in Greenwood Cemetery in Haverhill. (Image courtesy of Marion Ettlinger and Alison Cagle.)

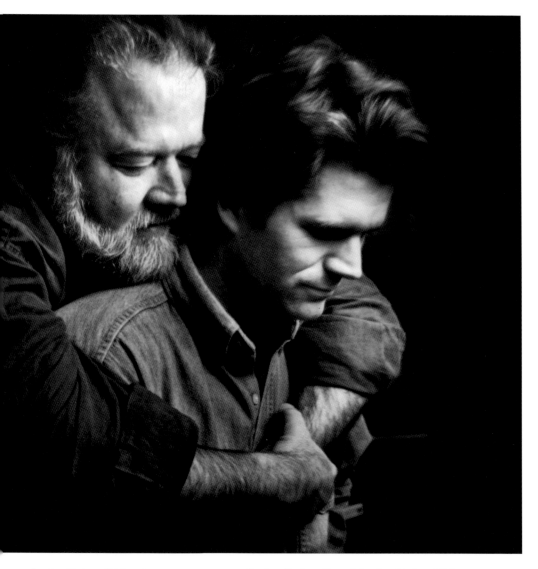

Andre Dubus III (LEFT)
Andre Dubus III (1959–present) was born in Louisiana but grew up in Haverhill. His novel *House of Sand and Fog* was a finalist for the National Book Award and was later made into an Academy Award–nominated film. He has taught at Harvard University, Tufts University, Emerson College, and the University of Massachusetts, Lowell. Dubus's 2011 book *Townie* is a look at his life growing up in Haverhill during the late 1960s and 1970s. (Image courtesy of Marion Ettlinger and Andre Dubus III.)

Andre Dubus II and Andre Dubus III from "Carrying" (ABOVE)
Andre Dubus and his son had a distant relationship until his accident. This tragedy brought the two authors closer together. After the accident, Andre would visit with his father and help him to train with weights to regain his strength. This photo was taken by Michelle McDonald to accompany an essay written by Andre Dubus II and published in the *Boston Globe Magazine*. The essay was about his two sons lifting him out of his wheelchair and carrying him where he needed to go. This photo has touched the hearts of all who have seen it, and many feel the love shared between these two men. (Image courtesy of The Collection, *Boston Globe*/Getty Images.)

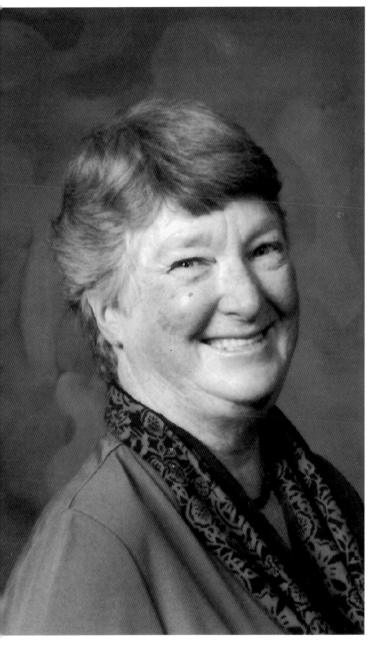

Patricia Trainor O'Malley
O'Malley (1937–present) was educated in Haverhill-area parochial schools before receiving a scholarship to attend Merrimack College, graduating with an AB in history. She also attended Georgetown University, where she studied political theory. Her first teaching experience was at a private academy in Washington, DC, teaching history, civics, and religion. After getting married and starting a family, she lived in Maryland, Ohio, and Boston before returning to Bradford in 1965. She has taught at many local colleges, including Bradford College, where her focus was local and New England history. While teaching at Bradford College, she required her students to work in cooperation with the Haverhill Historical Society, doing hours of volunteer work there. Pat was named Teacher of the Year at Bradford College in 1999. After returning to the area, Pat attended graduate school at Boston College, where she earned her PhD in modern English history. While working on her doctorate she extensively studied local history. Her dissertation includes a frequently cited study of the first four families in the Colonial town of Rowley, Massachusetts. O'Malley has written numerous articles and books as well, including *A New England City: Haverhill, Massachusetts* (with Paul Tedesco) in 1987 and seven books about Haverhill and Bradford (all for Arcadia Publishing). One of her first publications was *Sacred Hearts Parish, Bradford, Massachusetts: A 75th Anniversary History* in 1985. This Haverhill history book was used for many years at Haverhill High School in its local history course. She also presented summer courses on Haverhill's history to teachers in the late 1970s and has been a past member of various historical committees and leagues. It is O'Malley's hope that when people read and see photographs of the past they will be encouraged to appreciate their own family history and pass it down to the next generations. Her current project involves a collection of letters sent from Ireland at the end of the 19th century to the Donovans of Bradford. (Image courtesy of Patricia O'Malley.)

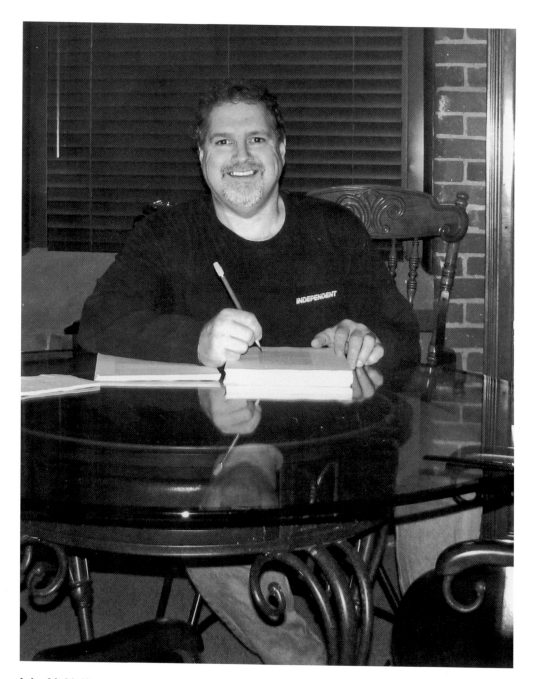

John M. McIlveen

Born in New Hampshire, McIlveen (1962–present) moved to Haverhill in 2002. He is an engineer, an editor, a technical writer, and an author and publisher of fiction (Bradford House/Twisted Publishing). He has owned a bookstore, worked in journalism, and co-written books on economics and industry. For nearly 20 years he has been the coordinator of Camp Necon, an annual writer/artist/fan convention held at Roger Williams University in Rhode Island. McIlveen is currently employed at MIT Lincoln Laboratory in Lexington, Massachusetts. (Image courtesy of John McIlveen.)

Richard Smyth

Smyth (1964–present) was born in New York and lived in Florida before moving to Haverhill in 1999. He has obtained English degrees from the University of Tampa and the University of Florida and currently works at both Cathedral High School in Boston and at Emerson College. His poetry has appeared in various publications including the *Tampa Review* and the *Kansas Quarterly*, and he is the editor and publisher of the poetry journal *Albatross*. Smyth has been very active in the Haverhill community, serving on the Cultural Council, being an active member of the Universalist Unitarian Church, and leading a peaceful protest against the Iraq war in 2003. (Image courtesy of Richard Smyth.)

David Crouse

Crouse (1967–present) was born in Haverhill and attended Haverhill High School. He worked at Bradford College for four years until it closed in 2001. A teacher and short story writer, he has received numerous awards for his writing, including the Flannery O'Connor Award for Short Fiction (2005) and the Mary McCarthy Prize in Short Fiction (2008). Crouse currently lives in Alaska with his family, where he also writes and performs electronic music in local clubs. (Image courtesy of David Crouse.)

Christopher Golden

Golden (1967–present) was born in Framingham, Massachusetts, and has lived in Haverhill since 1993. He is a graduate of Tufts University and is an author of horror, fantasy, and suspense novels. He is especially known for the thriller series *Body of Evidence*, which was honored by the New York Public Library and was chosen as a Best Book for Young Readers by YALSA. He is also well known for his online animated series *Ghosts of Albion* (with Amber Benson). He is an award-winning author of novels, books for teens and young adults, comics, and scripts. His novels include *The Myth Hunters*, *Wildwood Road*, *The Boys Are Back in Town*, and *The Ferryman*. His young adult book titles include *Bikini*, *Poison Ink*, and *Soulless*. Golden has written and co-written many novels for the *Buffy the Vampire Slayer* series. He has also been an editor and a creator of video games. His novels have been published in 14 languages. (Image courtesy of Christopher Golden.)

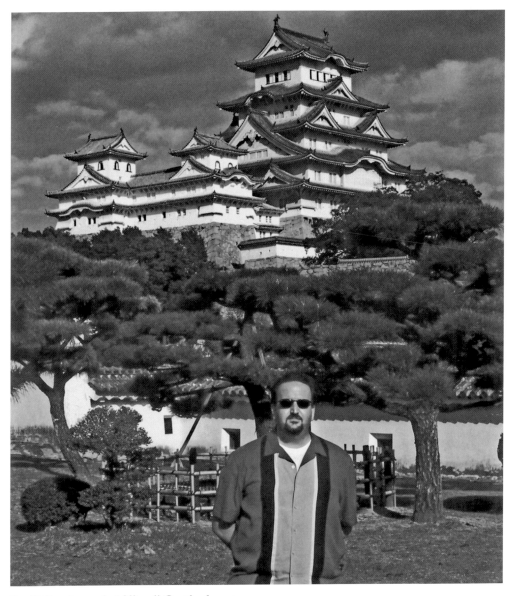

Scott Goudsward at Himeji Castle, Japan
Goudsward (1967–present) was born in New Jersey and moved to Haverhill when he was young. He graduated from Haverhill High School in 1985. Goudsward started to write after hearing Edgar Allan Poe's story *The Tell-Tale Heart* while in fifth grade. In 1992 he joined a local writers' group, which he is still a member of. He wrote his first novel *The Wishbringers* in 1994 and his first screenplay *Blood Farm* in 1997. His first published novel was *Trailer Trash*, published by Dark Hart Press in 2006. A few years later Goudsward edited the *Traps* anthology for Dark Hart. In 2001 production began on the short film *Granite Voices* based on one of Goudsward's short stories. *Granite Voices* premiered at the first New Hampshire Film Festival. Goudsward has co-written two nonfiction books, *Shadows Over New England* (2007) and *Shadows Over Florida* (2009), with his brother David. Both books were nominated for the Rondo Award and have made the HWA Stoker Award preliminary ballot. (Image courtesy of Scott Goudsward.)

CHAPTER THREE

Art

The object of art is to crystallize emotion
into thought, and then fix it in form.
François Delsarte

The citizens of Haverhill have always loved the arts. Perhaps this love was first shown to the world in the glorious styles produced by its shoe industry. Some of these magnificent designs can still be viewed at Buttonwoods Museum, home to the Haverhill Historical Society. Or maybe the arts began when Haverhill was building some of the grandest wooden ships to sail the seven seas. Or maybe it was first felt in the architecture of the magnificent homes that line some of Haverhill's streets. Who knows where and when this love of the arts began, but we know for sure that it is alive and well. Haverhill artists have stepped out into the world and made their mark. Illustrators like Bob Montana, who used Haverhill students to base his classic Archie characters on; artists like Francesco Ruocco, who used stained glass to create beautiful works of art; or sculptor Israel Levitan, who, while in the Navy, drew illustrations that were used in medical journals. Haverhill painters, sculptors, illustrators, and craftsmen have all shown the world their creative side. Today, the Greater Haverhill Arts Association is hard at work keeping this tradition alive. They host community events, hold classes, and do everything necessary to nurture the next generation of artists.

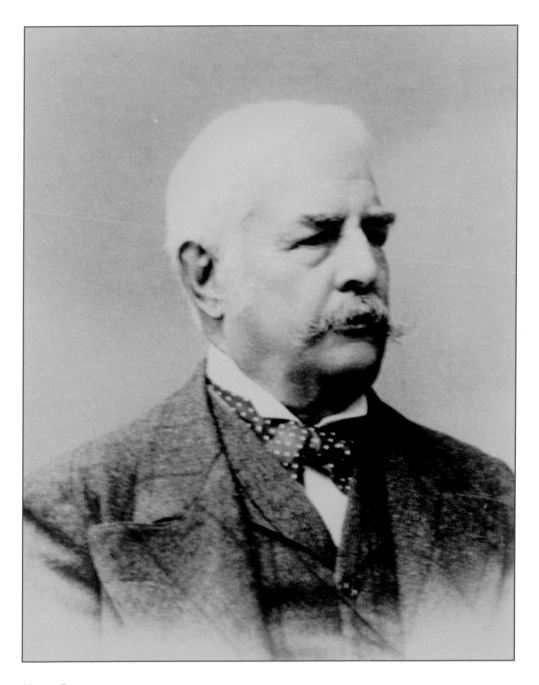

Henry Bacon
The son of the Reverend Henry and Mrs. Bacon, Bacon was born in Haverhill and lived at the Universalist Church parsonage on Kent Street for a short time. He enlisted in the Union Army in 1861, acting as a field artist for *Frank Leslie's Weekly* while a soldier in the 13th Massachusetts Infantry. He was wounded at Bull Run and discharged in 1862. Bacon then went on to study art in Paris in 1864. His important works of art are "Boston Boys and General Gage" and "Franklin Chez Lui a Philadelphia." He died in Cairo, Egypt, in 1912. (Image courtesy of HPLSC.)

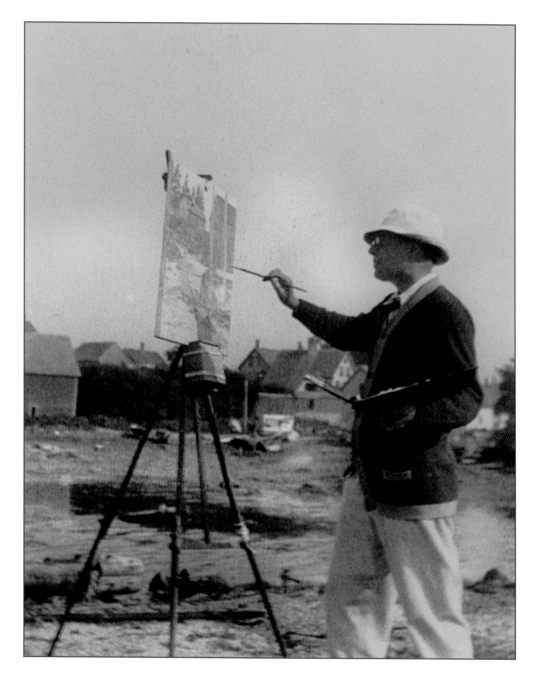

Sydney Marsh Chase Painting at Maine Coast c. 1915
Chase (1877–1957) lived in his grandfather's house on Mount Vernon Street his entire life. He was an 1895 graduate of Haverhill High School and a 1900 graduate of Harvard. A painter, illustrator, and writer, his works appeared in major magazines like *Harper's* and the *Saturday Evening Post*. Chase favored coastal subjects, portraying old salts and ocean scenes. According to Greg Laing, he requested that his remaining works be destroyed after his death, but the Haverhill Public Library has a number of his works still on file. (Image courtesy of HPLSC.)

Bob Montana in Bow Tie in Front of the Hangar Inn
Montana (1920–1975) was born in California and traveled with his parents on the vaudeville circuit, where he learned about comedy and writing humor. His family moved to Haverhill in 1936, where he attended Haverhill High School from 1936 to 1939. His artistic talent was unmistakable in high school, where he was an illustrator of both the school newspaper and his class yearbook. Montana was also known for keeping diaries of local events and stories, which he illustrated with cartoons of his school classmates and faculty (a copy of this diary is located in the Special Collections section of the Haverhill Public Library). He later moved to New York, studied at the Phoenix Art Institute, and at the age of 21 created Archie for MLJ's *Pep Comics* (1941). The Archie character was so successful that he was given his own comic book, *Archie No. 1*, which was released in November 1942. The comic book was later the catalyst for a Saturday morning television show, along with a hit single, "Sugar, Sugar," in 1960. His children remember contributing to his work by jotting down everyday events in their school day. If he used the idea, they got 25¢. The comic strip was set in the fictional town of Riverdale, which was based on Montana's high school days in Haverhill. The old soda fountains on Merrimack Street (Crown Confectionery and the Chocolate Shop) were the inspiration for the Chok'lit Shop in his strip. The story of Montana basing his Archie characters on his Haverhill classmates was revealed in an article written by Gerald Peary in the *Boston Globe* in 1970. The question of which student inspired which character is still debated in Haverhill all these years later. Besides the characters and the soda fountain, he also included the familiar *Thinker* statue in his comic strips, which now stands at the entrance to the current Haverhill High School. When Montana attended high school, it was in the building that is now city hall. His comic strip was famous for capturing the school days of American teenagers, just hanging out and having fun. He also served his country during World War II in the Army Signal Corps, where he drew coded maps and worked on training films. He and his family later moved to Meredith, New Hampshire, living in an old farmhouse and sailing on Lake Winnipesaukee. He died of a heart attack while cross-country skiing near his home in Meredith. (Image courtesy of HPLSC.)

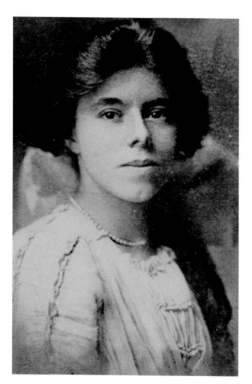

Gladys Emerson Cook
The Haverhill-born Cook (1895–1976) became world famous for her drawings of dogs and cats, as well as her Christmas cards and circus posters. She studied at the New York Art Students' League and was a fellow of the Royal Society of Arts of England and a member of the American Society of Illustrators. Cook worked in a variety of media, including charcoal, etching, oil paint, and pastels. (Image courtesy of HPLSC.)

Francesco Ruocco in Studio
Ruocco (1901–1970) was born in New York and moved to Haverhill in 1909, where he graduated from Haverhill High School. He studied art at both the Museum of Fine Arts School in Boston and the University of Rome, Italy. He began working at a stained-glass company in Boston before he started his own business in Haverhill on Washington Street in 1931. Many of the local churches contain his window designs, including St. Joseph's, Trinity Episcopal, St. Michael's, and St. Rita's, along with other locations such as Merrimack College in North Andover, Massachusetts. (Image courtesy of HPLSC.)

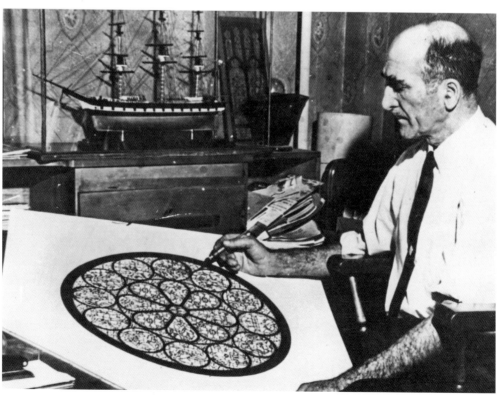

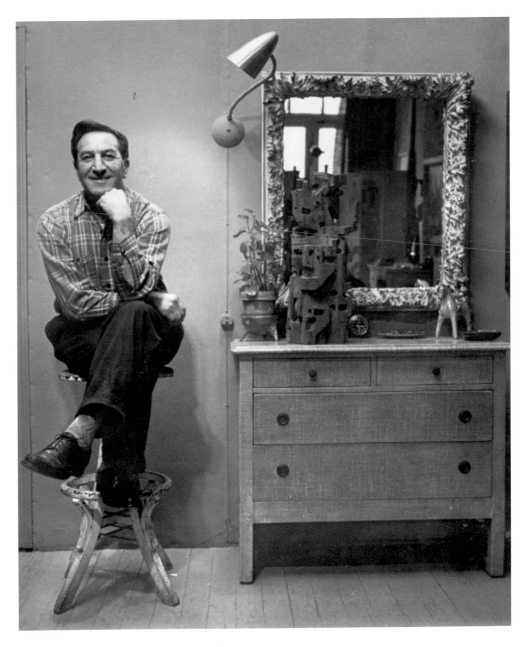

Israel Levitan with "Termite Tower"

Levitan (1912–1982) was born in Lawrence, Massachusetts, but lived on South Prospect Street in Haverhill as a young boy. He studied art at many schools, including the Art Institute of Chicago in 1939, where he won a scholarship to the Institute's summer colony in Wyoming in 1941. He also served in the US Navy, where he became a chief pharmacist's mate, drawing illustrations that were used in medical journals for naval hospitals. Levitan is most known for his sculptures, some in private collections and many in museums, including the Santa Barbara Museum of Art. He worked in a number of mediums: plaster relief, stone, clay, marble, and many varieties of wood, including ash, cedar, Douglas fir, and oak. (Image courtesy of Alicia Armstrong Gallery.)

Israel Levitan in Studio

Levitan studied sculpture in Paris with the French master Ossip Zadkine from 1950 to 1951. Upon his return to America, he set up a studio in New York City and exhibited his work in the Tenth Street galleries. He had one-man shows at the Artists' Gallery and the Barone Gallery, both in New York City, and at the University of California, Berkeley. His work has also appeared in many museums, including the Musée d'Art Moderne, the Brooklyn Museum, and the Philadelphia Museum of Art. (Image courtesy of Alicia Armstrong Gallery.)

Israel Levitan

One of Levitan's works, "Enrapture," which has a bird flight theme, was featured at the Whitney Museum of American Art in an annual sculpture exhibit in 1952. The *New York Times* praised his work, saying, "one of the best pieces in the show is a dancer's torso in a warm-colored wood in which the artist has captured well the thrust of a dancer's body." (Image courtesy of Alicia Armstrong Gallery.)

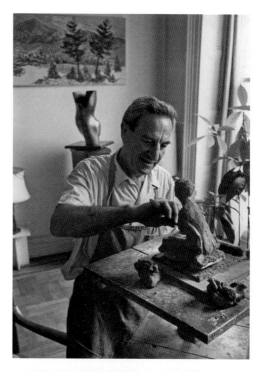

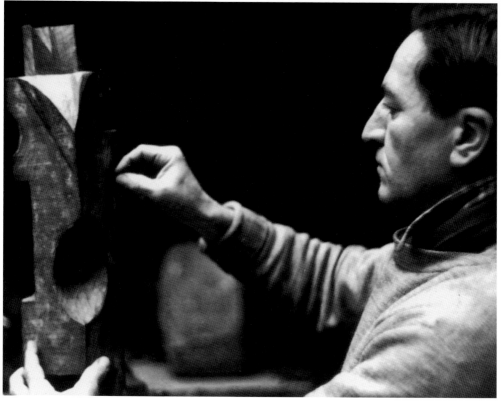

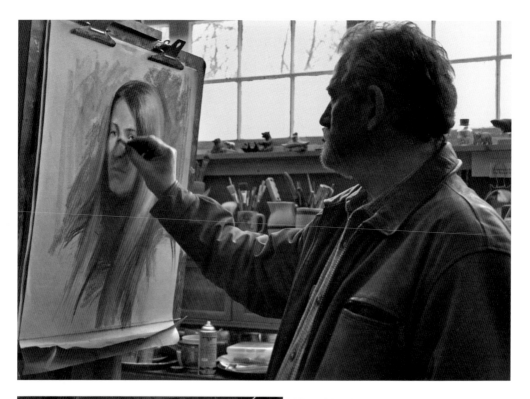

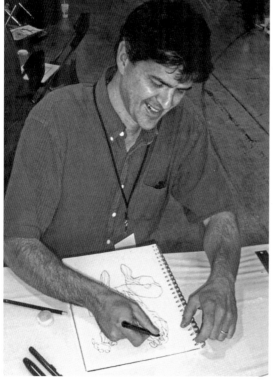

Mark Hayden

An accomplished artist, Hayden (1957–present) was born and raised in Haverhill and attended Montserrat College of Art. He runs the Hayden Studio of Fine Art, specializing in portraits in oils and pastels, and also teaches painting. Hayden is a member of many local art groups, including the Greater Haverhill Arts Association, the North Shore Art Association, and the Copley Society of Boston, where he reached Master status in 1993. (Image courtesy of Mark Hayden.)

Rick Leonardi Sketching Spider-Man

Leonardi (1957–present) was born in Philadelphia and grew up in Haverhill. He is a graduate of Dartmouth College (1979) and is a comic book illustrator who has worked for both Marvel Comics and DC Comics. He has drawn for *The Uncanny X-Men* and *Spider-Man 2099* series. He worked with Mike Zeck in designing the black-and-white costume Spiderman began wearing during the 1984 *Secret Wars* miniseries. (Image courtesy of Rick Leonardi.)

Michael Gould
As a child, Gould (1958–present) always enjoyed art, spending hours drawing pictures. Now an accomplished artist, Gould enjoys working in several mediums, including oils, watercolors, photography, pottery, and stained glass. He runs painting workshops at the Millvale Art Studio in Haverhill and has won many awards for his work, including Best in Show for the Advanced Category at the Haverhill Art Association Spring Show in 2011. Gould has taken classes with Haverhill's Mark Hayden, a Copley Society Master. (Image courtesy of PTP.)

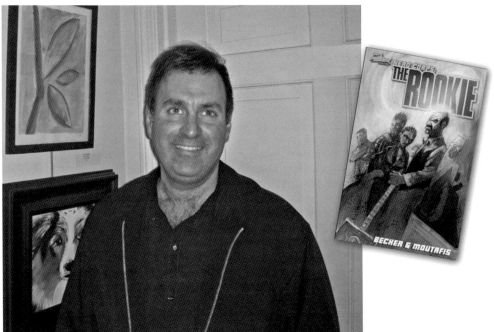

Greg Moutafis
Haverhill native Moutafis (1969–present) attended local schools until moving on to graduate from the Massachusetts College of Art in 1995. His artistic fields include illustration, design, and comic book art, and he was awarded the Xeric Foundation Comic Book Artists Grant in 1994. His published credits include *Negative Burn* from Caliber Press, *Johnny Raygun*, and *The Rookie*, a graphic novel from BabyShark Productions. Moutafis also collaborated with communications specialists at Children's Hospital in Boston to illustrate a picture system of icons to improve communication among impaired patients, family, and staff. (Image courtesy of PTP and Greg Moutafis.)

Stephen LaPierre

LaPierre (1963–present) attended Haverhill High School and the Massachusetts College of Art. He has taught at the Essex Art Center, the Greater Haverhill Artist Association, the North Andover Artist's Guild, and also gives private lessons. His collections have appeared in many local venues, including Northern Essex Community College, where his mural of the Bragg Block in Haverhill's Railroad Square hangs in the C-Building lobby. He has been painting in watercolors and tempera since 1980 and oils since 1992 in styles such as Plein Air, Realism, Impressionism, and Approximationism. His work has been published in newspapers like the *Haverhill Gazette*, the *Lawrence Eagle Tribune* and the *Chicago Sun-Times*. Many of his works feature local scenes like shops on Washington Street and local bridges. Some of these works were exhibited at a showing titled Haverhill Through an Artist's Eyes at Buttonwoods Museum a few years ago. The charity event raised over $3,000 for Buttonwoods. (Image courtesy of Stephen LaPierre.)

CHAPTER FOUR

Sports and Entertainment

*The most delicate, the most sensible
of all pleasures, consists in promoting
the pleasure of others.*
Jean de la Bruyère

Haverhill's citizens have always loved sports. They still follow and support the local school teams and do the same for professional teams such as the Boston Red Sox and the New England Patriots. Haverhill has also produced some remarkable sports stars. Whether it was with their prowess behind the wheel of a super-charged automobile, their running abilities on and off the track, their talent on the baseball diamond, or their skill riding horses, they have constantly made the crowds cheer and marvel at their athletic feats. Haverhill citizens love to be entertained, and a few citizens have made a career in the entertainment industry. These entertainers range from opera singers and actors to comedians and musicians. They have amused us with their comedy routines, their impersonations, their guitjo (half guitar, half banjo) playing abilities, and more. Our television stars have taken us from *The Big Valley* and *Dancing with the Stars* to space, the final frontier. The varied talents of Haverhill's citizens are nothing less than remarkable, and we hope this trend continues.

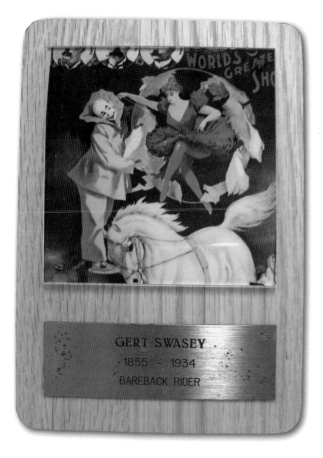

Helen "Gert" Swasey, Haverhill Citizens Hall of Fame Plaque
"Gert" Swasey was the 27th person inducted into the Haverhill Citizens Hall of Fame. During her circus career her likeness appeared on posters across the country. Her plaque, which hangs in the Haverhill Public Library, shows one of these posters. According to sources, while touring with "The Greatest Show on Earth" she was paid as much $20,000 per year. (Image courtesy of PTP.)

Helen G. Swasey Advertisement, The New York Clipper, December 16, 1882
Swasey was one of Haverhill's most colorful citizens. She had a flamboyant childhood riding her horses in her yard and on City streets, and an amazing career in the circus. City records show that the City of Haverhill purchased a little over 14 acres of land from the Swasey family in 1909 for $10,000. This land became Swasey Field. (Image courtesy of HPLSC.)

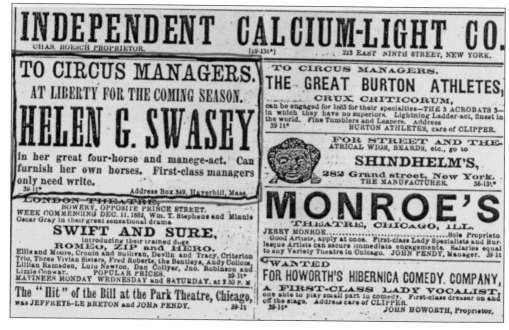

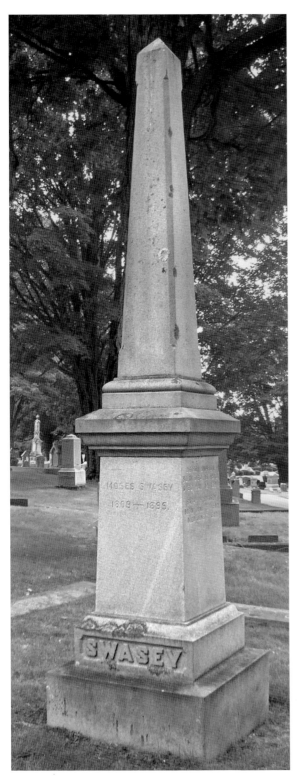

Swasey Family Monument, Linwood Cemetery

Swasey (1855–1934) was born in Haverhill in a large house on Essex Street, where her wealthy father built a circus ring in the yard for her to practice riding her horse. Her father also built her a playhouse in the yard that reportedly cost $2,000. Neighbors remember her as a beautiful girl, flying through town on Merrimack, Main, Summer, and Mill Streets on her horse, with her hair streaming out behind her. Swasey attended Bradford Academy, but she was not happy in school; she found out that if a student married she would be expelled, so she got married. The marriage only lasted about an hour. Afterward she was sent to live with her aunts in Illinois, and it was there that she answered an ad to join the circus. She later moved to Chicago, working as a circus performer with various circuses including Barnum & Bailey, riding horses and performing stunts such as leaping through a ring of fire. Eventually she moved home to care for her ailing father, but due to litigation concerning his estate, Swasey was left with little money and spent her last years living as an eccentric in a two-room apartment near the railroad tracks on Washington Avenue. At one time, vaudeville star Maggie Cline arranged for Swasey to receive $10 a week from an actors' association, but over time the payments stopped due to lack of funding. One of Haverhill's famous poets, Winfield Townley Scott, penned a poem titled "Gert Swasey," which recalls the young girl riding through the town and joining the circus. It reads in part, "To travel like a gypsy / To dress like a queen / To see all the world that she'd never seen / That was never the world where she had been. / Not a Dow nor a Sanders nor a Saltonstall / Unless they paid to get in. / And / After thirty-five years to come home again." The city paid for her funeral, burying her beside her parents in Linwood Cemetery in Haverhill. (Image courtesy of PTP.)

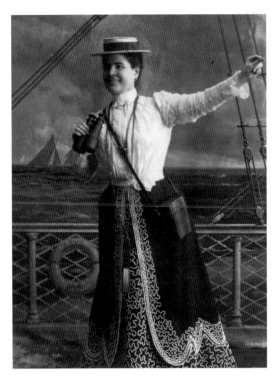

Maggie Cline
Haverhill native Cline (1857–1934) was born on Lancaster Street. She left home at the age of 16 to begin her career on the stage, becoming a successful vaudeville performer. Her most famous song, which she used for 30 years, was "Throw Him Down McCloskey." Cline performed for almost 50 years, becoming known as "The Irish Queen." She is buried in New York. (Image courtesy of HPLSC.)

Harold Chandler "Hal" Janvrin in Red Sox Uniform
Janvrin (1892–1962) was born in Haverhill and educated in Boston. His baseball career included stints with the Boston Red Sox, Washington Senators, St. Louis Cardinals, and Brooklyn Robins. While playing for the Red Sox, he helped them to win both the 1915 and 1916 World Series. During World War I Janvrin served as a second lieutenant with the Massachusetts Infantry. He is buried in Exeter, New Hampshire. (Image courtesy of Library of Congress.)

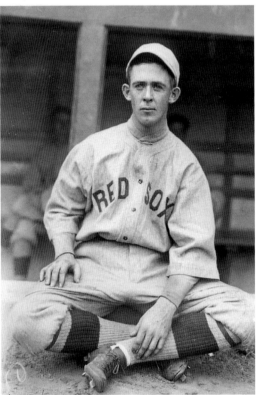

Cora Chase as Gilda in *Rigoletto*, c. 1921 (RIGHT)
Chase (1892–1984) was born in a house on Arlington Street and was a 1909 graduate of Haverhill High School. She studied voice in Italy from 1909 to 1919, making her European debut in Busseto, Italy, the birthplace of Verdi, where they presented her with a gold medal. She later became the prima donna of the Metropolitan Opera Company of New York, debuting in 1921 as Gilda in *Rigoletto* before signing a recording contract with RCA Victor. She became known as America's greatest coloratura soprano. Chase later retired from the opera after marrying Samuel T. Williamson, whom she met while they were students at the Burnham School. Williamson was a *New York Times* reporter who rose to become the editor of *Newsweek*. They settled in the artsy community of Rockport, Massachusetts, Cora's favorite place, where she remained a prominent resident in the community right up until her death. (Image courtesy of HPLSC.)

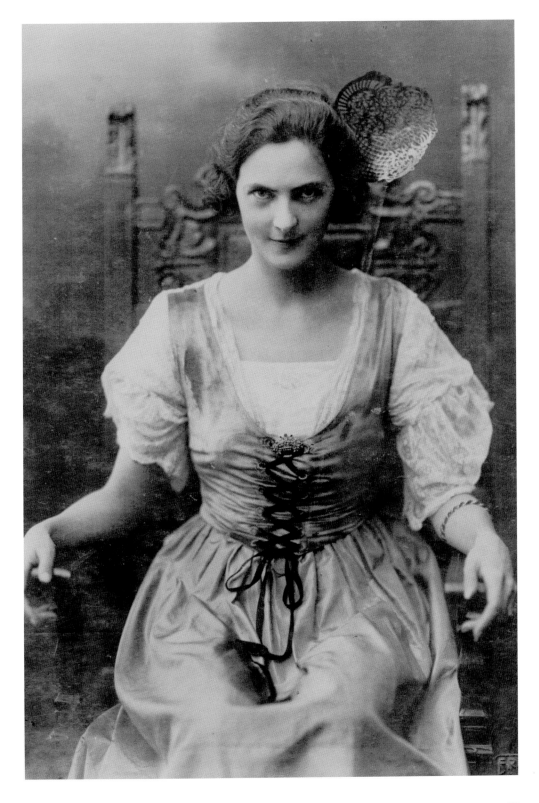

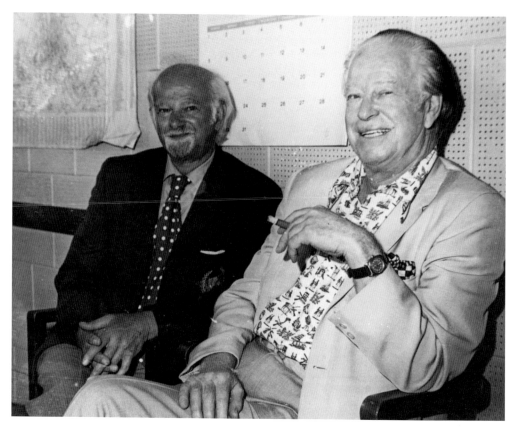

Louis Alter (right) with His Brother at the *Haverhill Gazette* Office, 1971

Alter (1902–1980) began playing the piano in silent film theaters at the age of 13. While a student in high school, he led a jazz band that played at school dances. He studied at the New England Conservatory of Music under Stuart Mason. In 1924, he moved to New York, where he was hired as the accompanist to Nora Bayes, a vaudeville star, touring with her in America and Europe for five years until her death in 1928. His predecessor as Bayes's accompanist was George Gershwin. Alter sometimes worked as a song arranger, experience that helped him when he began writing his own songs. Over the course of his career, Alter had several songs published, including "To Be Loved," "I'm In Love with You," "Manhattan Serenade," and his first hit, "Blue Shadows." "Manhattan Serenade" became the theme music for *Easy Aces*, a popular radio program. He was also well known for several highly impressive orchestral impressions of New York, many songs for motion pictures, and numerous Broadway stage songs. In 1929 he moved to Hollywood, and two of his movie songs were nominated for Academy Awards: "Dolores" and "A Melody from the Sky." One of the songs he wrote for Broadway, "My Kinda Love" (lyrics by Jo Trent) was later made famous by Bing Crosby. Some of the Broadway musicals he wrote for were *Sweet and Low* (1930) and *Ballyhoo* (1931). He also performed and coordinated entertainment for the troops when he joined the Air Force in 1941, earning him a special citation. He wrote hits for countless stars such as Frank Sinatra, Louis Armstrong, and Fanny Brice. In 1943 he appeared twice with the Los Angeles Philharmonic at the Hollywood Bowl as a piano soloist. He was inducted into the Songwriters Hall of Fame in 1975. He eventually moved back east to Manhattan, where he died after coming down with pneumonia. More recently, his song "Do You Know What It Means to Miss New Orleans" was revived and used in Spike Lee's *When the Levees Broke* (2006) and in a sketch by Billy Crystal on HBO's *Comic Relief 2006*. He is buried in the Children of Israel Cemetery in Haverhill. (Image courtesy of HPLSC.)

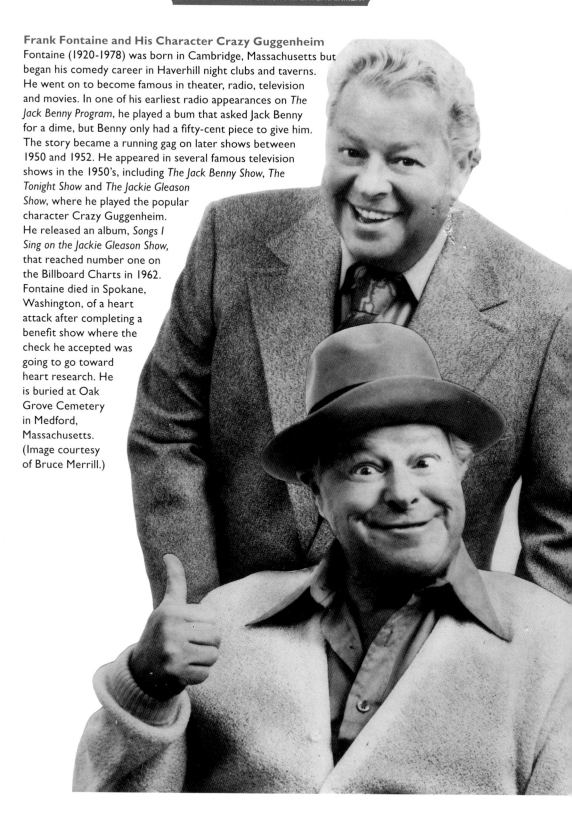

Frank Fontaine and His Character Crazy Guggenheim
Fontaine (1920-1978) was born in Cambridge, Massachusetts but
began his comedy career in Haverhill night clubs and taverns.
He went on to become famous in theater, radio, television
and movies. In one of his earliest radio appearances on *The
Jack Benny Program*, he played a bum that asked Jack Benny
for a dime, but Benny only had a fifty-cent piece to give him.
The story became a running gag on later shows between
1950 and 1952. He appeared in several famous television
shows in the 1950's, including *The Jack Benny Show*, *The
Tonight Show* and *The Jackie Gleason
Show*, where he played the popular
character Crazy Guggenheim.
He released an album, *Songs I
Sing on the Jackie Gleason Show*,
that reached number one on
the Billboard Charts in 1962.
Fontaine died in Spokane,
Washington, of a heart
attack after completing a
benefit show where the
check he accepted was
going to go toward
heart research. He
is buried at Oak
Grove Cemetery
in Medford,
Massachusetts.
(Image courtesy
of Bruce Merrill.)

Oliver Wendell Silva
"Ollie" Silva (1929–2004) grew up on a farm in Topsfield, Massachusetts, one of 16 children. He later moved to Haverhill, his home during his outstanding racing career at several local tracks, as well as national tracks in numerous states. In 1949 he started the Dracut Speedway in Dracut, Massachusetts, before serving for two years in the Army, stationed in the Netherlands. At the Pines Racetrack in Groveland, Massachusetts, a rivalry developed between Ollie "Quick" Silva and his competitor, Don "Big Daddy" MacLaren. This rivalry lasted until the Pines closed in 1974. During his illustrious racing career, Silva had one of the winningest cars in New England. In 1965 Silva was one of the driving forces behind the New England Super Modified Racing Association (NESMR), which used Star Speedway in New Hampshire as its home track. He went on to win 179 races with this organization. In July 1978 he was involved in a crash that ultimately ended his career, but he was so far ahead in points that even though he didn't race for the rest of that year, he still won the series. He was also known for building his cars on a budget, visiting local junkyards for parts, and even once using an International Scout frame. He was a very quiet, modest, and classy person, always well dressed and not wrapped up with his fame. A well-known quote of his was "the radius of the third and fourth corner does not change on the last lap." A friend of his compared the Pines Racetrack to Fenway Park, saying the Pines was Fenway and Ollie was Ted Williams. Very few people make a living out of auto racing, but Ollie did. (Image courtesy of Wes Pettengill.)

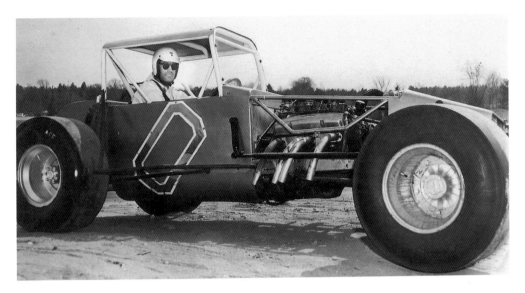

Ollie Silva in Super-Modified Car
This photograph was taken in 1965 at Lee Raceway in Lee, New Hampshire, the only tri-oval racetrack in the country. The car is a former LeBonte Brothers super-modified car that Silva bought, which was known for the six deuce carburetor setup. He went on to win the 1967 Point Championship in this car. (Image courtesy of Wes Pettengill.)

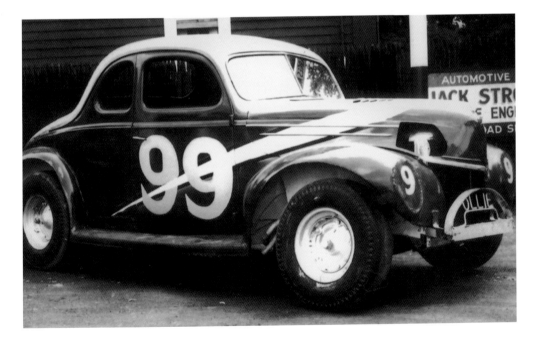

Ollie Silva in 1940 Ford
Built by Ray Farnell in the mid-1950s, this race car was known for the flathead V-8 engine under the hood. Silva reportedly had his first win in it. Check out the front bumper on Silva's race car that spells out "OLLIE." (Image courtesy of Wes Pettengill.)

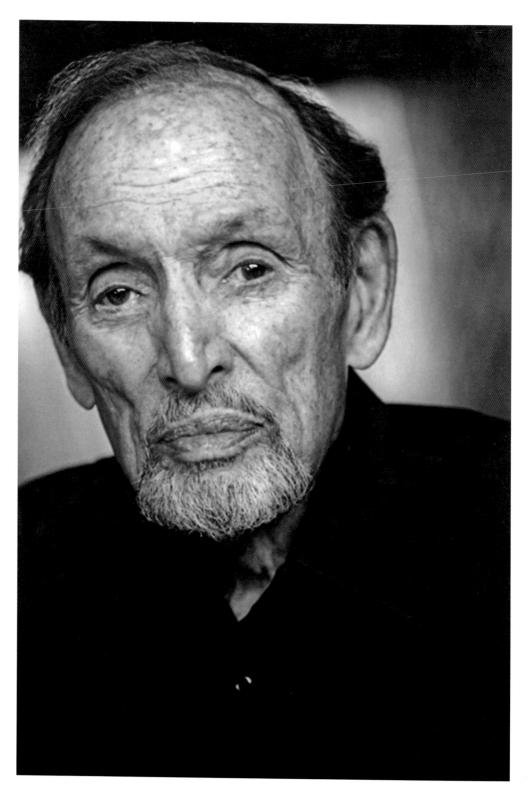

Joseph Ruskin (LEFT)
Ruskin (1924–present) was born in Haverhill and went on to become one of the most admired actors in Hollywood. He got his start as a theater major at Carnegie Tech, appearing at the Pittsburgh Playhouse. After performing in stock theater in Rochester, New York, he moved to New York City, working in off-Broadway productions and on television. From there he headed to Hollywood to begin a long and successful career on television and in movies. Ruskin's TV appearances included *The Twilight Zone* (1960 & 1962), *The Untouchables* (1961–1963), *Gunsmoke* (1962 & 1966), *The Man from U.N.C.L.E.* (1966–1967), and *Mission: Impossible* (1966, 1967, 1969, 1972). He is the only actor to have appeared on four *Star Trek* television series: *Star Trek* (1968), *Star Trek: Deep Space Nine* (1994–1996), *Star Trek: Voyager* (1999), and *Star Trek: Enterprise* (2001). His movie credits include *The Sword and the Sorcerer* (1982), *Prizzi's Honor* (1985), and *Star Trek: Insurrection* (1998). He was awarded the Lucy Jordan Recognition Award from the Actors' Equity Association in 2003 and the Ralph Morgan Award from the Screen Actors Guild in 2011. (Image courtesy of Joseph Ruskin and Valerie Yaros.)

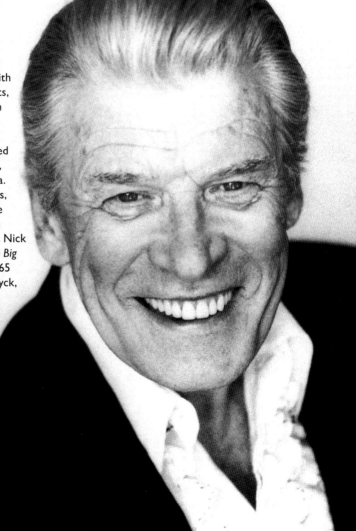

Peter Breck
Though born in New York, Breck (1929–present) lived in Haverhill with his grandparents because his parents, who were musicians, were often on the road. After serving in the Navy aboard the aircraft carrier the USS *Franklin Delano Roosevelt*, he attended the University of Houston in Texas, where he studied English and drama. After performing in several theaters, he moved to Los Angeles, where he began appearing in movies. Breck is perhaps most known for his role as Nick Barkley on the television series *The Big Valley*, which aired on ABC from 1965 to 1969 and starred Barbara Stanwyck, Richard Long, Linda Evans, and Lee Majors. In the 1970s he returned to directing and acting in theater, which was his first love, before moving to Vancouver, British Columbia, with his family, where he taught acting and ran the Breck Academy for 10 years. (Image courtesy of Diane and Peter Breck.)

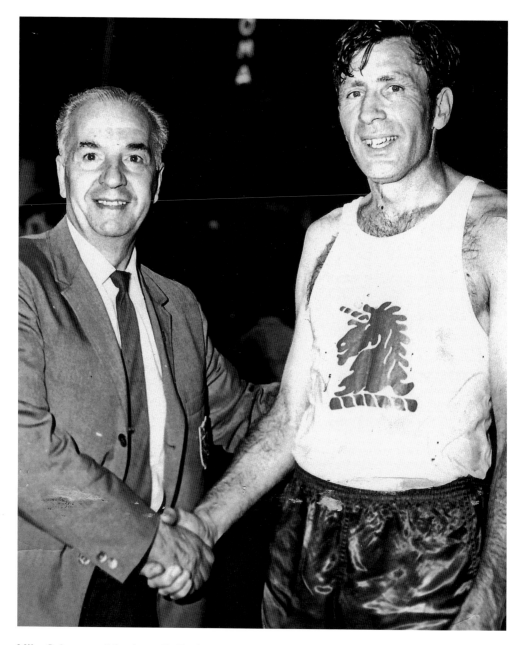

Mike Schena and Anthony B. Sapienza, Sons of Italy Road Race
Tony Sapienza (1929–1987) was born in Lawrence, Massachusetts, and later moved to Haverhill to begin teaching. He graduated from Boston College in 1953 with a master's in education and began teaching in Haverhill in 1960. He became chairman of the math department at Haverhill High School in 1975 and was the cross-country coach for some time. He had always been involved in running, first in high school and later as the captain of the track team in college. Sapienza died of a heart attack after collapsing at the finish of a race at Brown University in Rhode Island in 1987. After his death, both the School Committee and City Council voted to name the high school track after him and to place a plaque on the site in his honor. (Image courtesy of Toni Donais.)

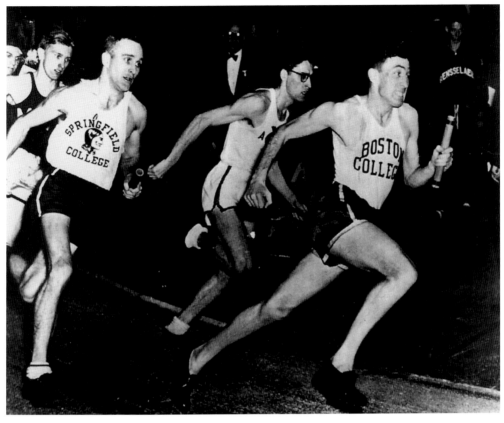

Anthony Sapienza Running the "College Mile" at Boston College
While attending Boston College, Sapienza was the captain of the cross-country team. He later went on to run in a number of races both locally and around the world and was featured in an article in *Life* magazine in 1952. One of his proudest accomplishments was finishing fourth in the Boston Marathon in 1958. He also finished sixth in the Olympic Trials in 1963. (Image courtesy of Toni Donais.)

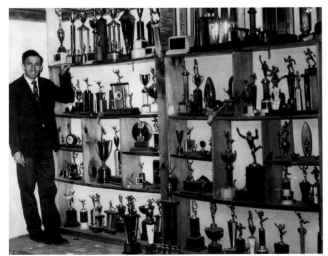

Anthony Sapienza and his Trophies, 1960
Over the course of his running career, Sapienza went on to run in many races worldwide and accumulated shelves full of trophies for his wins. He held many records, including the most track, field and running championships in New England at the time of his death. His family and friends started the Sapienza Memorial Road Race to honor his passing and to begin a scholarship in his name. This race was held for 25 years until its finale in July of 2011. (Image courtesy of Toni Donais.)

Billy Fellows (LEFT)
Fellows (1935–present) lived in houses on North Avenue and Winona Avenue as a child. He attended the Walnut Square School and the Haverhill Trade School on Wingate Street. From eighth grade through his high school graduation in 1953, he dabbled in entertainment with his school friends; they called themselves the Wheatley Brothers and played local town halls. In 1957 he headlined New York's Latin Quarter and Radio City and opened the Las Vegas Riviera Hotel. Fellows also wrote for legends such as Sammy Davis Jr. and Arthur Godfrey. After his success in New York and Las Vegas, he appeared in *Kings Go Forth* with Frank Sinatra, Tony Curtis, and Natalie Wood. This exposure led to appearances on more than 100 television shows from 1975 to 1984, including *The Ed Sullivan Show*, *The Mike Douglas Show*, *The Merv Griffin Show*, and *The Tonight Show*. He was a writer, composer, and entertainer who was the first person to develop the use of live music played over recorded tracks. He played major venues until 1993, when he began to specialize in cruise entertainment. On cruise ships he was the opening act for celebrities such as John Davidson, Vikki Carr, and Dionne Warwick, later becoming a cruise headliner in his own right in 1993, a job he still very much enjoys to this day. He currently lives in Connecticut. (Image courtesy of HPLSC.)

Michael J. Ryan in Red Sox Uniform
Born in Haverhill in 1941, Ryan began his baseball career as a catcher for the Boston Red Sox in 1964, helping the "Impossible Dream" Red Sox win the 1967 American League pennant. He later played for the Philadelphia Phillies and the Pittsburgh Pirates. After his playing career he managed and coached in the minor leagues, later moving to coaching at the major league level. He currently lives in Wolfeboro, New Hampshire. (Image courtesy of Boston Red Sox.)

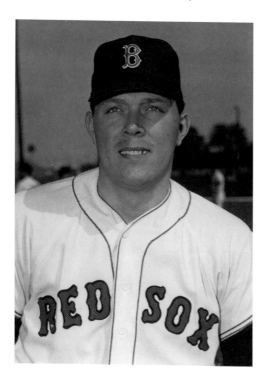

Gerald Ashworth with His Olympic Gold Medal
Ashworth (1942–present) was born in Haverhill and attended Dartmouth College, where he was the captain of the track team. He went on to win a Gold Medal at the 1964 Tokyo Olympic Games, which were the first to be telecast internationally, running the second leg of the United States 4x100 Relay Team. He also either tied or set numerous world track records. Haverhill issued a 325th Anniversary Commemorative Medal in 1965 that features Ashworth's image. (Image courtesy of the US Olympic Committee.)

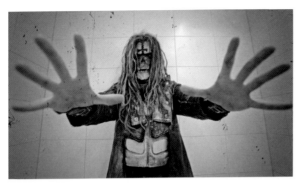

Rob Zombie in Full Stage Makeup
Rob Zombie's first horror film was *House of 1000 Corpses* (2003), which he directed and wrote. *Halloween* (2007) became the highest-grossing film in the Halloween series. He has directed all of his own music videos as well as ones for Ozzy Osbourne, Powerman 5000 (his brother Spider One's band), and Black Label Society.

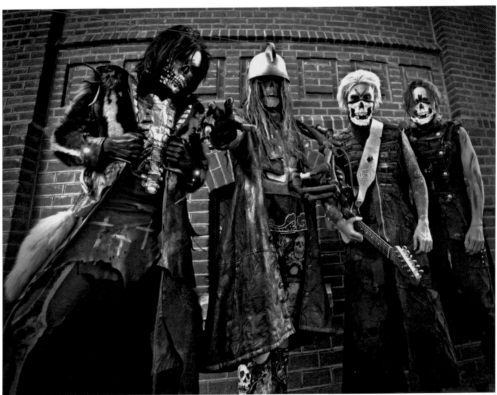

Rob Zombie (ABOVE AND RIGHT)
Born Robert Bartleh Cummings in Haverhill in 1965, the future Rob Zombie attended local schools. He has had a long music career, first as a member of the band White Zombie (1985–1998), known for their heavy metal music and outlandish scary appearance, and later as a solo artist. He has also gained fame as a film director (most notably the 2007 remake of *Halloween*), screenwriter and film producer, comic book writer, and director of music videos. He has been nominated for a Grammy Award seven times and has sold over 15 million albums worldwide. He formed his own solo band in 1998 (image shows Piggy D., Rob Zombie, John 5, and Ginger Fish). Their album *Hellbilly Deluxe* contained the hit singles "Dragula," "Living Dead Girl," and "Superbeast." He is well known for his theatrical appearance, including his legendary dreadlocks. The band has toured with Lacuna Coil, Alice Cooper, and Godsmack, and Zombie has supplied backing vocals for Lynyrd Skynyrd on their album *God & Guns*. (Images courtesy of Sarah Martin and Rob Zombie.)

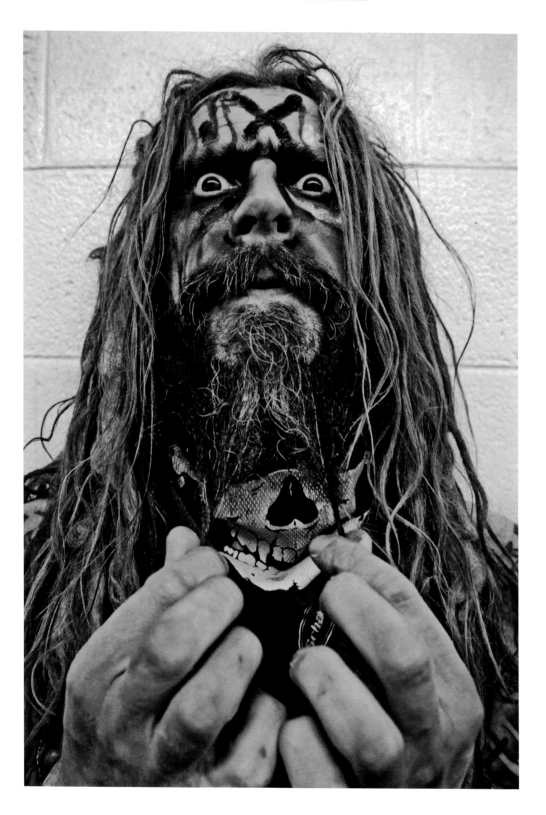

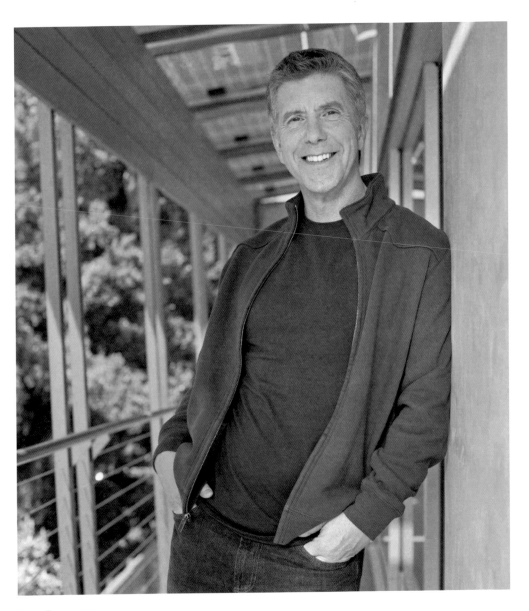

Tom Bergeron

Bergeron (1955–present) was born in Haverhill and began his entertainment career as a DJ at WHAV, Haverhill's local radio station, before moving on to WHEB, a radio station out of Portsmouth, New Hampshire. On WHEB he played music and comedy records, and conducted unusual interviews. His first television job was on *Granite State Challenge*, a local game show, after which he joined WBZ-TV in Boston where he appeared on *Evening Magazine* (1982–1987) and later, *People Are Talking* (1987–1993). In the 1990s he was featured on WBZ Radio, where he had an early-morning radio show titled *The Tom Bergeron Show*. He also appeared on WBZ-TV as a commentator and reporter on the noon newscast. Bergeron joined *ABC News* as a guest host on *Good Morning America*, and was the host of *Hollywood Squares*, *America's Funniest Home Videos*, and *Dancing With the Stars*. His book *I'm Hosting as Fast as I Can* was released in 2009 and details parts of his career, along with family stories and his Zen insights. (Image courtesy of Tom Bergeron and Alejandra.)

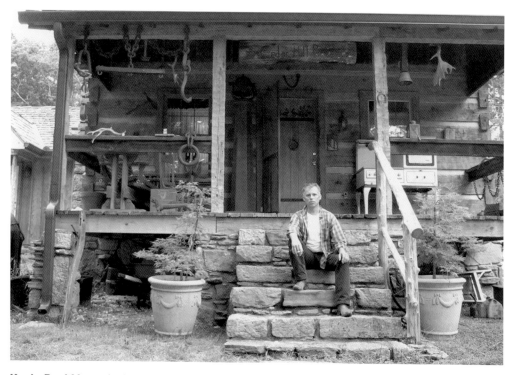

Kevin Paul Hayes in Front of the Johnny Cash Cabin, Tennessee
A member of the Nashville-based string band Old Crow Medicine Show, Hayes (1964–present) is a 1982 graduate of Haverhill High School. Old Crow Medicine Show plays folk, bluegrass, and country music and has been recording since 1998. Hayes played guitar for three years before switching to the guitjo, a percussive instrument. The band made their debut at the Grand Ole Opry in 2001 and has also opened for the Dave Matthews Band and performed at the Telluride Bluegrass Festival. They were nominated for an Americana Music Award in 2007. (Image courtesy of Kevin Hayes.)

Jonathan Shain
Shain (1967–present) was born in Haverhill and became interested in playing the guitar at a young age. He attended Governor Dummer Academy (now the Governor's Academy) in Byfield, Massachusetts, where he joined a student rock band. He later formed the band The Partisans with friends, playing local venues. He attended Duke University where he was introduced to the region's folk music, graduating in 1989. Since 1986 he has been based in Durham, North Carolina. (Image courtesy of Jon Shain.)

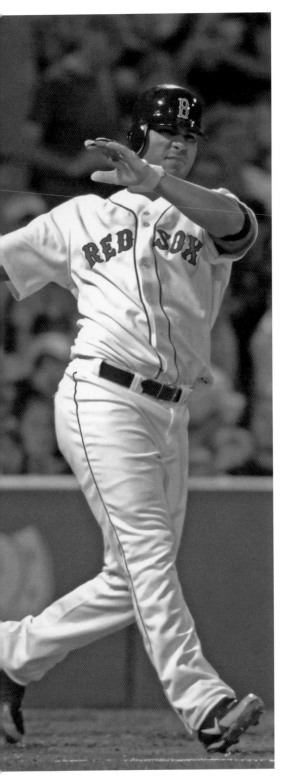

Carlos Peña in Red Sox Uniform

Peña (1978–present) was born in the Dominican Republic, moving to the United States at age 12. He is a 1995 graduate of Haverhill High School. He later attended Wright State University in Ohio, then Northeastern University, where he studied electrical engineering. He began his professional baseball career with the Texas Rangers, before moving on to the Oakland Athletics, Detroit Tigers, New York Yankees, Boston Red Sox, Tampa Bay Rays, and most recently the Chicago Cubs. In addition to sports, Peña is involved with Big Brothers Big Sisters of America and also helped with the relief efforts after the 2010 earthquake in Haiti. (Image courtesy of Brian Babineau/Boston Red Sox.)

Spider One

Born Michael David Cummings in Haverhill, Spider One (1968–present) is the younger brother of Rob Zombie. As a child he became interested in science fiction, horror, comic books, and music. He began studying art at the School of the Museum of Fine Arts in Boston but decided on a music career instead. In 1991, he formed the metal band Powerman 5000, which has enjoyed success with hit songs like "When Worlds Collide," and later launched his own recording label, Megatronic Records. He is also becoming successful in television and filmmaking. (Image courtesy of Spider One.)

CHAPTER FIVE

Business

The art of winning in business is in working hard
– not taking things too seriously.
Elbert Hubbard

Throughout the centuries the city of Haverhill has served as an incubator for many business ventures and ideas, influencing not just the United States but the entire world, with high achievers in publishing, telecommunications, manufacturing, motion pictures, retail, patent law, and health care. Some of Haverhill's businessmen have gone on to become giants in their fields. Names like Bell, Lahey, Macy, and Mayer all have Haverhill to thank for giving them their start. Although Haverhill has helped to shape the business world, we cannot forget the small-business owners who have served the citizens from the town's earliest days. Businesses with names like Barrett's, Mitchell's, and Buchika's once lined Haverhill's streets. Some names may now be forgotten, names such as Thomas Hale, who ran the ferry that crossed the Merrimack River, or Samuel Wilson, who served Haverhill for 47 years, first as a "hack" driver and then as a taxi owner. Today, small-business owners still assist the people of Haverhill by giving them superior customer service. Businesses such as The Schwinn Shop, Kimball Tavern Antiques, The Comic Book Palace, Carter's Ice Cream, Arthur Sharp Hardware, and the new Willow Spring Vineyards are there to meet the needs of today's customers. These businesses, and others like them, work to make Haverhill a better place to live.

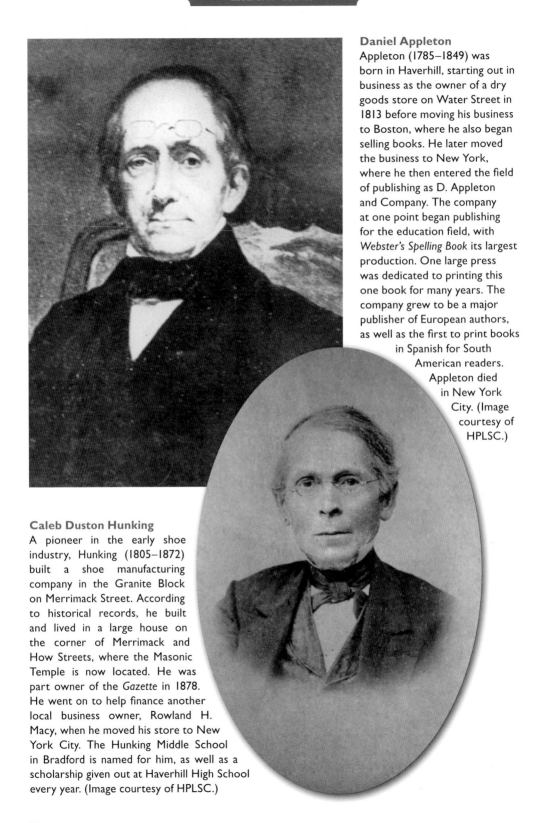

Daniel Appleton

Appleton (1785–1849) was born in Haverhill, starting out in business as the owner of a dry goods store on Water Street in 1813 before moving his business to Boston, where he also began selling books. He later moved the business to New York, where he then entered the field of publishing as D. Appleton and Company. The company at one point began publishing for the education field, with *Webster's Spelling Book* its largest production. One large press was dedicated to printing this one book for many years. The company grew to be a major publisher of European authors, as well as the first to print books in Spanish for South American readers. Appleton died in New York City. (Image courtesy of HPLSC.)

Caleb Duston Hunking

A pioneer in the early shoe industry, Hunking (1805–1872) built a shoe manufacturing company in the Granite Block on Merrimack Street. According to historical records, he built and lived in a large house on the corner of Merrimack and How Streets, where the Masonic Temple is now located. He was part owner of the *Gazette* in 1878. He went on to help finance another local business owner, Rowland H. Macy, when he moved his store to New York City. The Hunking Middle School in Bradford is named for him, as well as a scholarship given out at Haverhill High School every year. (Image courtesy of HPLSC.)

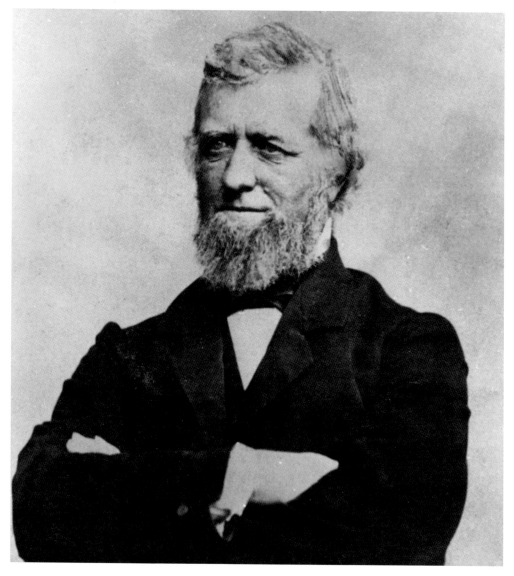

Ezekiel J. M. Hale

Hale (1813–1881) lived in Haverhill all his life. He studied at Bradford Academy and Dartmouth College, where he studied law. He took over his father's textile business at Little River and then operated a large textile mill in South Groveland that was a major supplier of flannel to the Union Army during the Civil War. He went on to become Haverhill's most renowned philanthropist, donating land and money to build a local church and a hospital, along with providing funds to establish a library. For the library, he gave land on Summer Street along with $30,000. According to his will, the trustees of his estate gave $50,000 and an estate on Kent Street for the hospital. The location ended up being unsuitable, so instead land on Kenoza Street became the site of this early hospital. Hale also commissioned the bronze statue of Hannah Dustin in 1879. Hannah Dustin was the first woman to have a monument erected in her honor in the United States, but that stone monument is no longer in Haverhill. The bronze statue is the only statue of a woman in Haverhill and we believe it is the nation's first statue to a woman. (Image courtesy of HPLSC.)

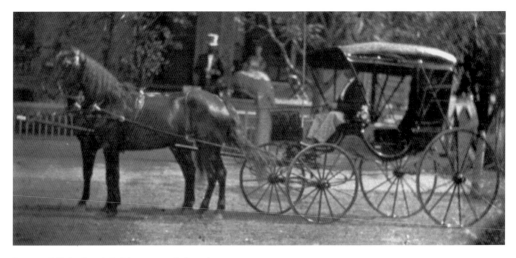

James Nichols with Horse and Carriage
This photograph is believed to show James Nichols in front of his home on Summer Street. In 1872 on a visit to England, he was stirred to create a new home to be built out of native rock. Construction began in 1873 and was completed in 1875. Called Winnekenni Castle after the Algonquin Indian word meaning "very beautiful," Nichols's home overlooks Lake Kenoza. (Image courtesy of HPLSC.)

Winnekenni Castle, Home of James R. Nichols
A prominent site in Haverhill is Winnekenni Castle, a summer home that was the site of many of Nichols's chemical and agricultural experiments. At one time it was known as Winnekenni Towers and was described as "one of the most beautiful estates in New England." The area had always been a favorite recreational spot for many residents, some of whom formed The Kenoza Lake Club in 1859, of which Nichols was the chairman. It is now run by the Winnekenni Foundation, and many local community events are held there. (Image courtesy of HPLSC.)

James R. Nichols (RIGHT)
Nichols (1819–1888) was born in West Amesbury, Massachusetts (now Merrimac, Massachusetts), and came to Haverhill in his youth as a drugstore clerk. He studied medicine under Dr. Kendall Flint and attended medical lectures at Dartmouth College, later establishing a drugstore on Merrimack Street in Haverhill in 1843. He went on to found the Haverhill Monday Evening Club and the Whittier Club. Nichols generously gave a gift of 1,000 volumes as the basis for a town library to the newly incorporated town of Merrimac. Nichols is also known for several inventions such as a soda water dispenser, a fire extinguisher, and an improved hot-air furnace. (Image courtesy of HPLSC.)

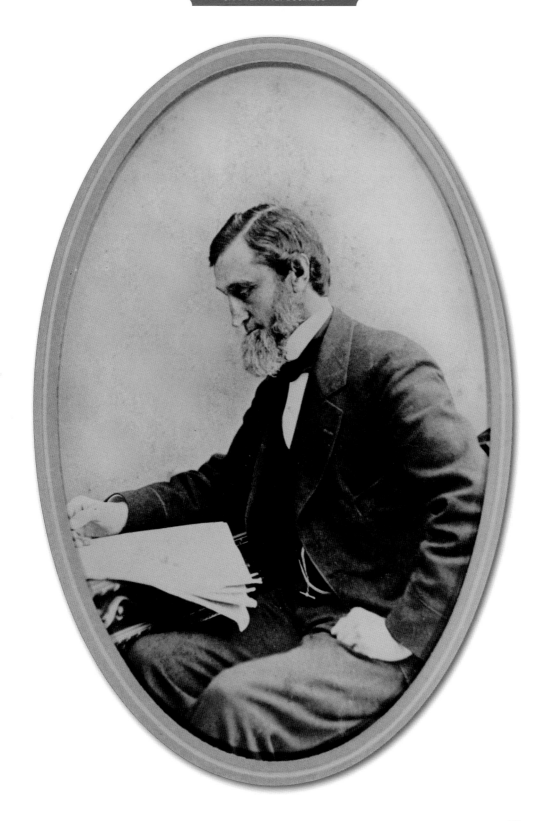

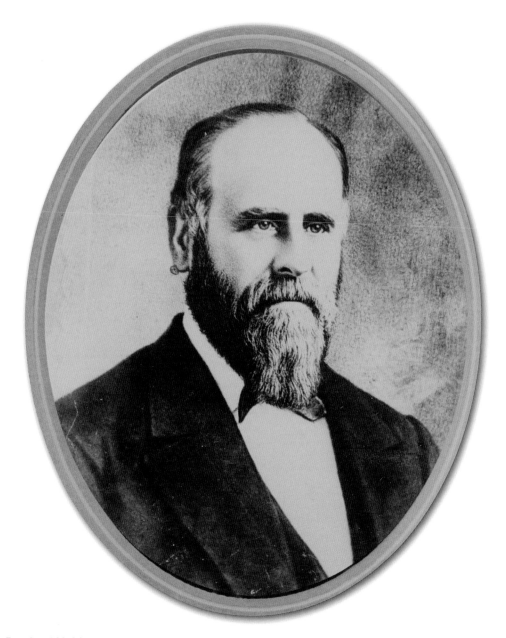

Rowland H. Macy
The founder of R.H. Macy's department stores, Macy (1822–1919) began his career at a dry goods store he opened on Merrimack Street in 1851. He pioneered business techniques along with new marketing and advertising methods, including selling for cash only. His business policy was "His goods are bought for cash, and will be sold for the same, at a small advance." Macy received generous financing from Caleb Dustin Hunking, helping him to build a nationally known business. He sold his Haverhill store in 1858, and with his funds he opened his New York City store on 14th Street. Today this store now occupies almost an entire city block. Many people credit him as the creator of the modern-day department store. Even the now-famous Macy's Thanksgiving Day Parade had a modest start in Haverhill. The first parade was held on July 4, 1854, drawing only about 100 spectators on a hot day. (Image courtesy of HPLSC.)

Thomas S. Sanders

Sanders (1839–1911) was born in Danvers, Massachusetts, then moved to Haverhill where he built "Birchbrow," his 40-room estate overlooking Plug Pond, and became a successful leather merchant. He became acquainted with Alexander Graham Bell when Bell was tutoring Sanders's six-year-old deaf son, Georgie. He later became the chief financial backer of Bell (while he was developing the telephone) and then served as the first treasurer of the Bell Telephone Company, which he founded with Bell, Thomas Watson, and Gardiner Hubbard in 1877. While in Haverhill Sanders was involved with the first business telephone calls ever made. He died in Derry, New Hampshire. (Image courtesy of HPLSC.)

Alexander Graham Bell

Although Bell (1847–1922) was not a Haverhill native, he did spend much of his time here, both tutoring the deaf son of Thomas Sanders and conducting some of his experiments in the basement of the Sanders home on what was then Pond Street (now Kenoza Avenue). It was from this house in 1877 that a telephone line was extended to city hall so that Bell could display his invention to the public. (Public domain image.)

Haseltine Monument, Elmwood Cemetery
George Haseltine (1829–1915), born in the Ward Hill section of Haverhill, was one of the most successful patent lawyers of his time, gaining fame worldwide for his achievements. He graduated from Dartmouth College in 1854, becoming the college's first president, a position he served in for 25 years. As a lawyer, he went on to operate one of the largest patent law practices in the country, leading to patent reforms in both England and Germany. His law career took him all over the world, but he eventually set up a practice in New York City in 1876. Dr. Haseltine never forgot his roots, and in his will he bequeathed numerous donations to local organizations, including the Ward Hill Church of Christ, the First Congregational Church of Bradford, Bradford Academy, Dartmouth College, the Elmwood Cemetery, and the Hale Hospital. A large monument, which Dr. Haseltine made arrangements for years before his death, was erected in Elmwood Cemetery in 1916. At the time of his death in 1915, he was the oldest living graduate of Dartmouth College. (Image courtesy of PTP.)

Walter Tenney Carleton
Born in Everett, Massachusetts, Carleton (1867–1900) attended school in Connecticut before becoming a student at the Carleton School for Boys in 1884, a school founded by his father Isaac N. Carleton. He graduated from Dartmouth College in 1891, taught briefly at the Carleton School, and later worked as a publisher in Boston for a short time. Carleton began working for Western Electric in 1892, a job which took him to Japan. It was there that he met the two Japanese men with whom he would cofound the NEC Corporation in 1899. Shortly after returning to Bradford in 1900, he developed appendicitis and died at the Hale Hospital. (Public domain image.)

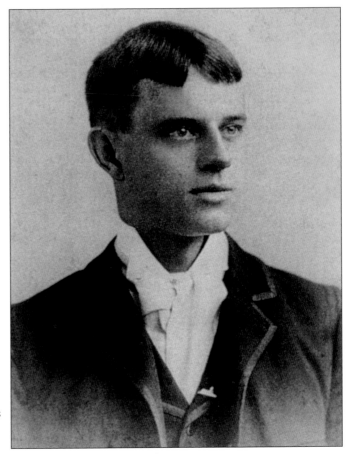

Thomas H. Bailey
Bailey (1851–1922) moved to Haverhill as a child and later ran a drugstore on Merrimack Street that sold a variety of items, including beauty products and cigars. Bailey's store also contained a soda fountain, like most drugstores of that era. He enjoyed photography, and many of his photographs can be found in the Special Collections at the Haverhill Public Library. Some of his photographs appear in other Arcadia books on Haverhill. (Image courtesy of HPLSC.)

The Ayer Brothers (George, Phineas, and Walter)
These brothers were prominent hat manufacturers in Haverhill with a business on Washington Street. In an 1865 Haverhill directory their advertisement reads, "Ayer Brothers, wholesale manufacturers of black and colored wool hats." The Ayer name was very well known in Haverhill, with roots going back to about 1647. At one point Lake Saltonstall was named Ayer's Pond and the area around it was called Ayer Town. (Image courtesy of HPLSC.)

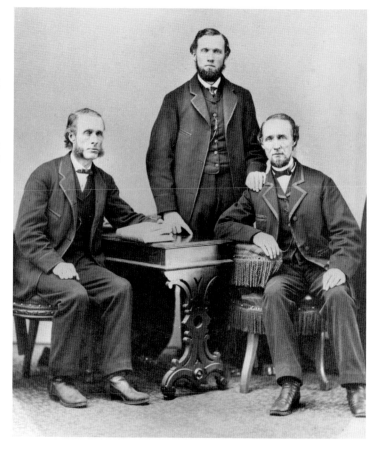

Daniel Hunkins Shoe Shop, Built in 1850
Not all of Haverhill's shoe workers worked in the factories located downtown; some had their own shoe shops, mainly in the countryside. These shops were called "ten footers," and here the workers took the cut leather from the manufacturers and sewed them into shoes. The shop pictured was donated to the Haverhill Historical Society in 1958 by the ancestors of Daniel Hunkins, the local shoemaker who built it. (Image courtesy of PTP.)

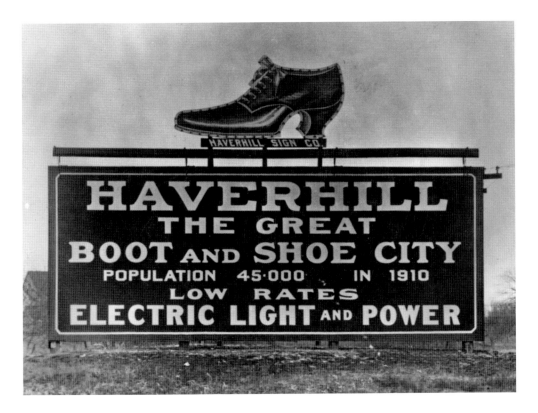

Boot and Shoe City Sign

The shoemaking industry was an integral part of Haverhill's economy for many years, beginning with the individual shoe shops and progressing up to the large shoe factories that dominated the downtown. According to historical records, around 1815, a man by the name of Phineas Webster is credited with being the first person to manufacture shoes only by wholesale. This led others to follow, including Samuel Chase in 1815, Warner Whittier in 1818, and Daniel Hobson in 1828. In the early part of the 19th century, most of the shoes were stitched by hand in homes, but everything changed with the invention of the sewing machine. The first Singer sewing machine, which cost $400, was used by Moses How in his shop in 1857. According to documented records, production expanded from 20,000 pairs of shoes in 1811 to 1.5 million in 1830. By 1890 well over 11,000 men, women, and children were working in the factories. Much of the stitching was done by independent companies outside of the factories, and many of these companies were owned by women. At the peak of the industry, there were over 200 shoe factories operating in Haverhill, making the city a world leader in shoe manufacturing and gaining it the nickname "Queen Slipper City" due to the fancy shoes that were being produced and sold worldwide. Numerous blocks of buildings were erected for the manufacturing of shoes along the north side of the Merrimack River, from the area known as White's Corner to Railroad Square. A devastating fire on February 17, 1882, destroyed all except two buildings of the shoe district on Washington Street, but the city quickly rebuilt. During this time all local businesses were affected by the success and prosperity of the shoe industry, including the manufacturers who had magnificent homes built in the elite neighborhoods of the town. Many awards were won by Haverhill's shoe manufacturers at both the Columbian Exposition in Chicago (1893) and at the Exposition of Paris (1899). All of this growth led to Haverhill being responsible for 10 percent of the country's shoe production in the first part of the 20th century. Unfortunately everything changed after World War II, and the shoe industry declined dramatically. This photograph and the shoe shop photograph honor the thousands of shoe workers who helped to make Haverhill the city that it is today. (Image courtesy of HPLSC.)

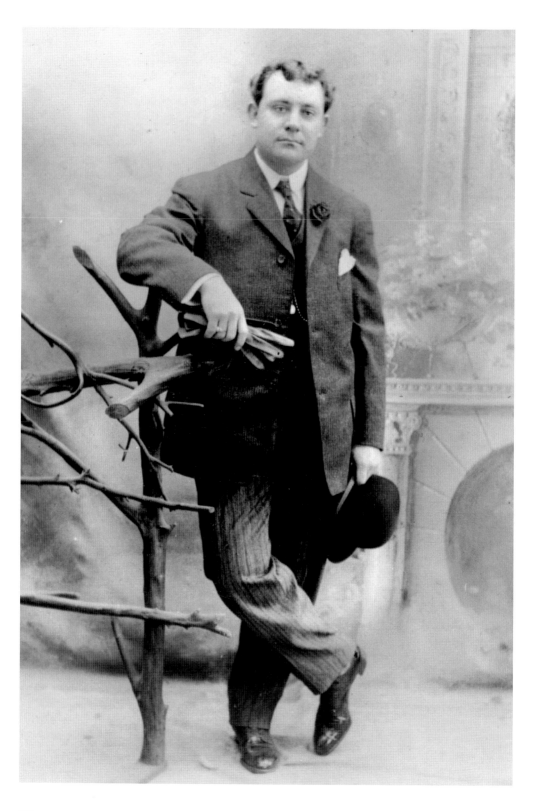

George P. Nichols (LEFT)
Nichols (1877–?) was born in Sparta, Germany, the son of a dentist. He came to America in 1893 to pursue better opportunities, first settling in New York City, then Long Island, Lowell, Massachusetts, and eventually, Haverhill, where he began a candy business with his cousin. He later established an ice cream business on West St., a business that grew so successful that he eventually was servicing all of Essex County and several beach resorts in the area. At one time, his ice cream business profits exceeded a quarter of a million dollars. He later used some of his various business profits to purchase the Webster Hotel on Washington Square, spending $125,000 to remodel and refurnish the hotel, making it one of the most modern properties of its kind between Boston and Portland, Maine. The name was changed to the Nichols Hotel and serviced its patrons for many years. Mr. Nichols went on to purchase other downtown properties, including the Pearson Block and the Abbott Building on Merrimack Street, which he also remodeled into one of the premium office buildings in the downtown. He lived with his family in a house at 719 Main Street. (Image courtesy of HPLSC.)

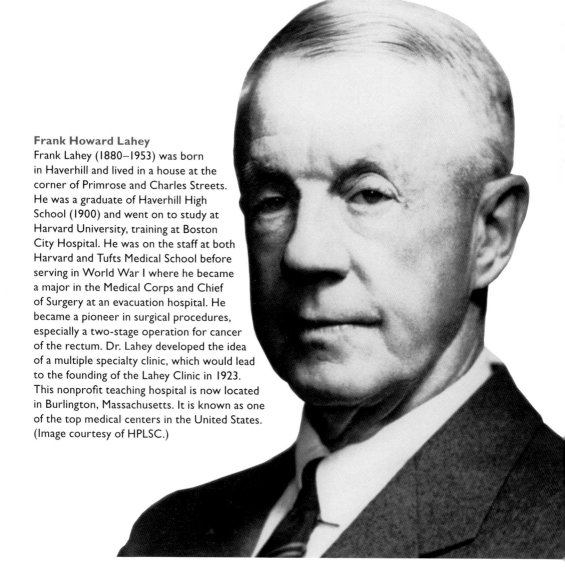

Frank Howard Lahey
Frank Lahey (1880–1953) was born in Haverhill and lived in a house at the corner of Primrose and Charles Streets. He was a graduate of Haverhill High School (1900) and went on to study at Harvard University, training at Boston City Hospital. He was on the staff at both Harvard and Tufts Medical School before serving in World War I where he became a major in the Medical Corps and Chief of Surgery at an evacuation hospital. He became a pioneer in surgical procedures, especially a two-stage operation for cancer of the rectum. Dr. Lahey developed the idea of a multiple specialty clinic, which would lead to the founding of the Lahey Clinic in 1923. This nonprofit teaching hospital is now located in Burlington, Massachusetts. It is known as one of the top medical centers in the United States. (Image courtesy of HPLSC.)

Louis B. Mayer in Black Coat, Lafayette Theatre

Born Lazar Meir in the Ukraine, Mayer (c. 1885–1957) lived in St. John, New Brunswick, Canada, as a youth. At the age of 19 he moved to Boston, becoming a scrap metal dealer. He purchased and renovated his first movie theater, the Gem Theater, a former burlesque house, in Haverhill in 1907 and renamed it the Orpheum. Within a short time he owned all five of Haverhill's theaters and created the Gordon-Mayer partnership with Nathan H. Gordon, then the largest theater chain in New England. After that venture he went on to create Metro Pictures Corp. with Richard A. Rowland before moving to Los Angeles and forming his own production company. Mayer's biggest breakthrough was in 1924 when the owner of the Loews chain merged Metro Pictures and Mayer Pictures into Metro-Goldwyn, which was later renamed Metro-Goldwyn-Mayer. He went on to become the highest paid executive in the United States, earning $1.3 million in 1937 as the head of MGM. This made him the first person in US history to earn a million-dollar salary. He died of leukemia and is buried in Los Angeles. (Image courtesy of HPLSC.)

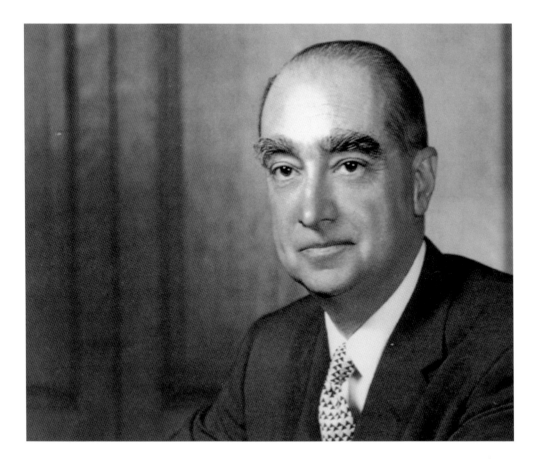

Louis H. Hamel

Hamel (1898–1975) was born in Exeter, New Hampshire, and later moved to Haverhill and attended local schools such as Bartlett and Currier. He began working at an early age in the cutting room of the Webster and Webber Shoe Company before using his savings to open his own business on Washington Street at the age of 17. As his business grew, he moved to a larger building where his business, dealing in upper leathers and the cutting of shoe trimmings from remnants, occupied an entire floor. By his third year in business he was earning $25,000 per year. He eventually settled the business on Essex Street and incorporated with his brothers as the L.H. Hamel Company in 1921. The company became the largest producer of shoe linings in the United States. At the age of 36, Hamel was the principal figure in the shoe industry. He learned the process of leather tanning from a gentleman in Peabody, Massachusetts, incorporating his own style to achieve the desired product. He named this invention "Nu Process Kid," which was kidskins made without two of the traditional steps. Mr. Hamel was well known for his progressive management outlook, first supporting the formation of the Hamel Employees Credit Union and later offering bonuses and pension plans to his employees. Along with a small group of businessmen, he developed Merrimack College in 1947 and also helped to bring Western Electric Company to Haverhill during World War II. Western Electric occupied three of his company's buildings for 15 years while they were building the main plant on Osgood Street in North Andover, Massachusetts. The tannery closed in 1974 due to both low profits and the rising popularity of rubber sneakers. The Hamel family lived in a house built for them on South Main Street at the corner of Kingsbury Avenue on the site originally occupied by Bradford Academy. They moved into this house in 1929 with the first three of their seven children. The mill building on Essex Street was bought by Forest City and restored and converted to the Hamel Mills Lofts (condos). (Image courtesy of Ginny Hamel Heffernan.)

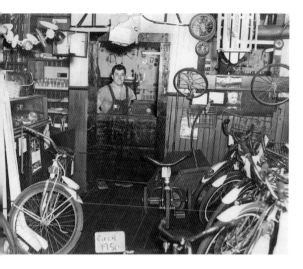

Boris Migliori, The Schwinn Shop
Migliori (1922–present) has been very well known as the owner of the H.R. Sawyer Schwinn Bicycle Shop in Haverhill since 1945. The shop was originally owned by a man named Herbert Richard Sawyer and was located at first on Fleet Street (which doesn't exist anymore), then on Bailey Street, and then at its present location on Ginty Boulevard. Before owning the store, Migliori served in the Air Corps overseas in 1942 on a B-24 as a tail gunner, earning numerous medals. After his retirement his son, Arthur Migliori, who had worked at the store most of his life, took over the operations. (Image courtesy of Arthur J. Migliori and Boris Migliori.)

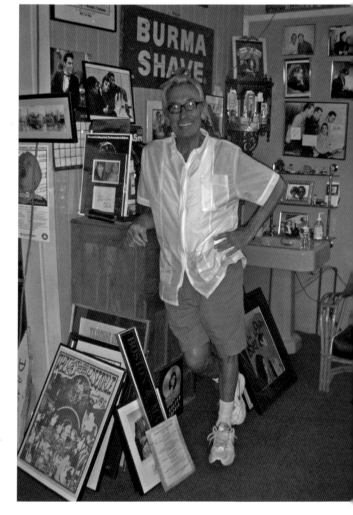

Bruce Merrill, The Clip Joint
A 1963 graduate of Haverhill High School, Merrill (1944–present) bought his barbershop, The Clip Joint, in 1973 from the previous owner, Onil Lampron, who had operated the shop for 45 years. It is an old-fashioned barbershop, complete with mint green chairs and a red-and-white-striped barbershop pole spinning outside. There is even a shoeshine parlor with the original brass foot holders for customers to rest their feet. Merrill has filled his shop with all kinds of memorabilia, both local and Hollywood-style, including classic advertisements for products like Burma Shave. (Image courtesy of PTP.)

Donald J. Atwood

Born in Haverhill, Atwood (1924–1993) lived on a small farm adjoining the home of John Greenleaf Whittier. During his youth he learned the value of hard work and became interested in mechanical things. He attended Worcester Academy for one year, served in the Army in World War II (1943–1946), and then attended MIT, where he studied electrical engineering and earned both a bachelor's and a master's degree. At MIT he was a graduate assistant of Dr. C. Stark Draper, who was the head of the Instrumentation Laboratory. It was while studying under Draper that Atwood contributed many patents to science and became an authority on navigation and guidance electronics and systems engineering. With his friend Fred Best, Atwood formed Dynatrol, a research company that developed and built inertial navigation and guidance systems for ballistic missiles. General Motors (GM) later purchased the company and Atwood was first named associate director of the Boston Research and Development Lab, moving up to director of engineering in Milwaukee in 1961. Here he oversaw the Apollo space program, where he was involved in launches at Cape Kennedy, led negotiations for contracts, and had overall management responsibility. During this time, he appeared on the television show *Today* with Hugh Downs, explaining what the Apollo 8 astronauts were experiencing on the dark side of the moon on Christmas Eve morning in 1968. In 1974 Atwood became the first general manager of the Transportation System Division at GM and the general manager of Delco Electronics Division. Between 1978 and 1986, he moved from a position as vice president and general manager of Detroit Diesel Allison Division to vice president of GM, helping to build the powerhouse of GM Hughes Electronics (GMHE). He later became deputy secretary of defense under George H.W. Bush, the number-two post at the Pentagon, working with Gen. Colin Powell during the Gulf War. (Image courtesy of HPLSC.)

Kendall C. Smith

Smith (1939–present) was born in Groveland and graduated from Bentley College with a BS in accounting and finance. As a youth, he delivered the *Haverhill Gazette* and worked in a local shoe shop during summers and school vacations. He was very involved in car racing at many of the local tracks, both racing and organizing events. His banking career began at Merrimack Valley National Bank in Andover, Massachusetts, in 1958, where he eventually moved up to become vice president. Smith moved on to Pentucket Five Cents Savings Bank (now called Pentucket Bank) in Haverhill in 1983, where he remained for 26 years until his retirement in 2010. During his career he was very involved in the community, including becoming the president of the NECC Foundation, Inc.; being chosen as the Haverhill Chamber Business Person of the Year (2001); and serving as the president, director, and a member of the Haverhill Rotary Club. He is well known for heading the "Pentucket Marching Band" (the staff of Pentucket Bank) in the annual VFW Santa Parade wearing his big white Mickey Mouse gloves. (Image courtesy of Pentucket Bank.)

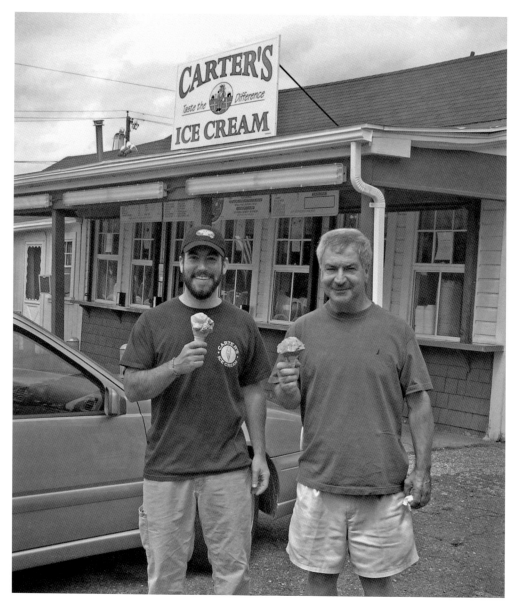

Jeremy and Gerard Dinan, Carter's Ice Cream

Jeremy Dinan (1977–present) and his father Gerard Dinan (1948–present) run the family-owned Carter's Ice Cream in Bradford, a business they bought 12 years ago but which has been around since about 1929. It was originally owned by the Sawyer family, who operated Sawyer's Dairy Farm across the street. Later, another owner, Lucien Archambeault, ran the ice-cream stand when the farm went out of business. He renamed it Carter's after the local dairy farm where he purchased his cream. The Dinans still have some of the old glass milk bottles from that farm with the slogan "Taste the Difference" stamped on the bottles, a slogan they still use today for their ice cream. The business went through a few more owners before the Dinans bought it from Sam Ambra. Like many other teenagers in the area, Jeremy worked at Carter's while he was a teenager. Now the Dinans keep up that tradition by offering other local teens a place to work in the summer. (Image courtesy of PTP.)

Patrick J. Lane, Arthur Sharp Hardware

Pat Lane (1954–present) was born in Lawrence but grew up in Haverhill, graduating from Haverhill High School in 1973. He owns Arthur Sharp Hardware, a well-known hardware and garden supply store on Middlesex Street in Bradford. The building, which was constructed in 1885, was first used as a grain wholesale business. Lane started working at the hardware store in high school, eventually moving up to manager, and then owner in 1982 when he purchased the business from the previous owner, Arthur Sharp, who had owned the business since 1955. Today Lane continues the tradition of employing local high school students to work there just as he did. (Image courtesy of PTP.)

James and Cindy Parker, Willow Spring Vineyards

James (1956–present) and Cindy Parker (1957–present) are the owners of Willow Spring Vineyards, the first winery to operate in Haverhill. They bought the land for the winery in 2000 and planted the first grapes in 2002. There was a large dilapidated barn on the property when they purchased it that had to be taken down. However, being native New Englanders, the Parkers decided to dismantle the barn and reuse as many timbers as possible to erect a new barn, which they would use for the winery and tasting room. While the winery was being built, the Parkers were able to have people sample and purchase their wine at the Haverhill Farmers' Market. The winery opened to the public in the autumn of 2011. (Image courtesy of PTP.)

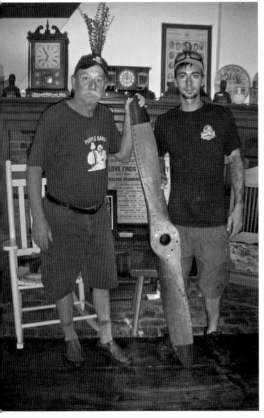

Glenn O'Leary, Comic Book Palace
O'Leary (1968–present) was born in Germany but lived in Haverhill from 1969 to 2006. He has been the owner of the Comic Book Palace on Primrose Street for 18 years, nurturing the imagination of children and adults alike throughout Haverhill and the Merrimack Valley. O'Leary carries all of the major comic books in his store, but his favorite character is Spider-Man. (Image courtesy of PTP.)

Craig and Ryan Wood, Kimball Tavern Antiques
The Wood family bought the historic Kimball Tavern at an auction in 2008, and they have restored the building into a successful antiques store. The tavern's history goes back to 1690, when it was built by Benjamin Kimball, and it is also where local residents met to found Bradford College in 1803. The family has done much work to restore the original charm, while still keeping many of the original features in place. One such feature is a room at the back of the store that is not original to the building but was added later. It was a one-room schoolhouse from the 1750s that was moved to its present location in 1872 and still contains working Indian shutters in the windows. Upstairs on the second floor is a safe room where the inhabitants could hide during an Indian attack. The Woods, whose family roots in the area go back centuries, value history and work to keep it alive in their store. (Image courtesy of PTP.)

CHAPTER SIX

Public Service

Act as if what you do makes a difference.
It does.
William James

Many Haverhill citizens have devoted their lives to the betterment of the city through their public service. We would like to thank all of those unsung heroes who have worked as curators, cemetery caretakers, janitors, neighborhood volunteers, and union representatives for their efforts. This list includes many walks of life: the clergy, teachers, police, firefighters, public works employees, doctors, historians, missionaries, reporters, elected officials, and all those who have served in labor organizations, clean-up groups, neighborhood watches, the various boys and girls clubs, and civic organizations. All have devoted their energies to making Haverhill a better and safer place to live and have worked together to make a difference. One small example of this was when six of Haverhill's mayors got together and posed for a photo for this book. They put aside personal differences to show their unified support for the city of Haverhill. It would be impossible to mention all of these good and caring people in this book. This is why we have chosen to include a few of the memorials scattered across town that honor them. It is our way of thanking many different people for their contributions.

The Saltonstall Family Memorial, Pentucket Cemetery
Nathaniel Saltonstall (1639–1707) was born in Ipswich, Massachusetts, and was a graduate of Harvard in 1659. In 1663 he married Elizabeth Ward, the daughter of John Ward, who was the first minister of Haverhill. They lived on the family estate, which is currently Buttonwoods, the home of the Haverhill Historical Society. He became the town clerk and then was appointed a judge of the Court of Oyer and Terminez, becoming involved in the Salem Witch Trials in 1692, but resigned shortly afterwards. Saltonstall was a member of the militia, defending against the Native Americans, where he was colonel of the North Essex Regiment. He died of consumption and is buried in Pentucket Cemetery. (Image courtesy of PTP.)

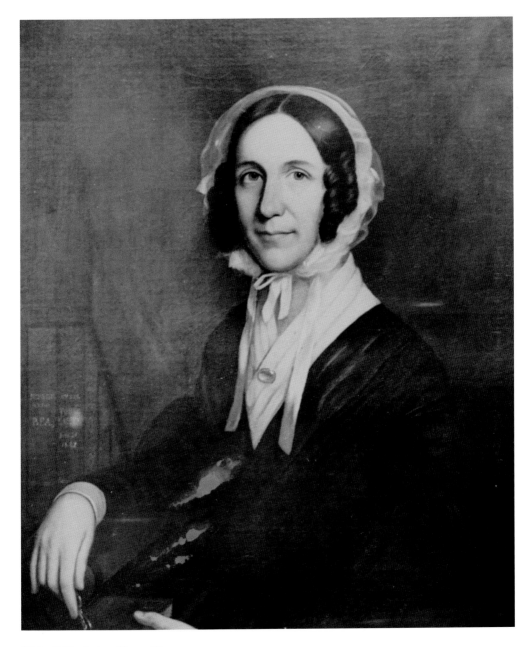

Abigail Carleton Hasseltine

Hasseltine (1788–1868) was born in Bradford and was a student at Bradford Academy for its first two terms. She later became a teacher in Beverly and later in Byfield before becoming the principal of Bradford Academy. She was a leader in higher education for females, encouraging them to study metaphysics, Latin, surveying, and celestial mechanics. After her death, students erected a stone at Elmwood Cemetery to her, which reads "A tribute of affection from her pupils to Abigail C. Hasseltine principal for 40 years of Bradford Academy whose life was disinterestedly devoted to their welfare and improvement." (Image courtesy of HPLSC.)

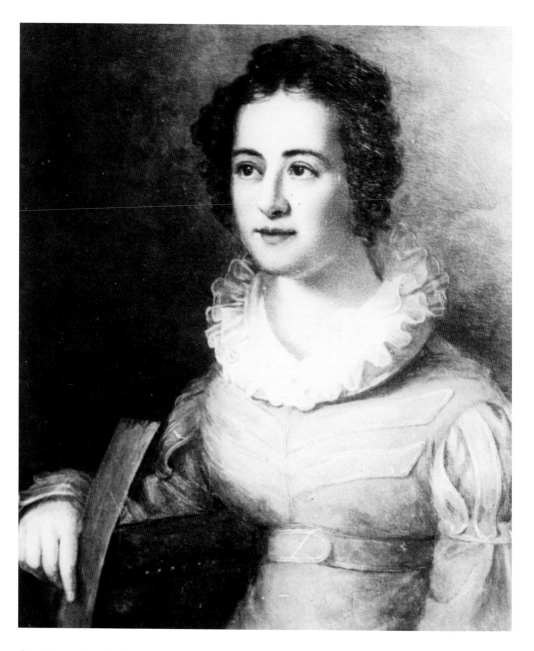

Ann Hasseltine Judson

Judson (1789–1826) was born in Bradford and attended Bradford Academy, later becoming a teacher. She married Rev. Adoniram Judson in 1812, and the couple moved to India, where she became the first American woman to go to a foreign country as a Christian missionary. Due to bad health she returned to America, lecturing on missions and writing a history of the Burmese mission. In 1823 Judson returned to Burma, where her husband was imprisoned. She repeatedly petitioned for his release, which she finally won, and also wrote numerous works during this time detailing the trials of the Burmese women. The couple later began a mission at Amherst, Burma, where she died of smallpox. She is buried there under a Hopia tree. (Image courtesy of HPLSC.)

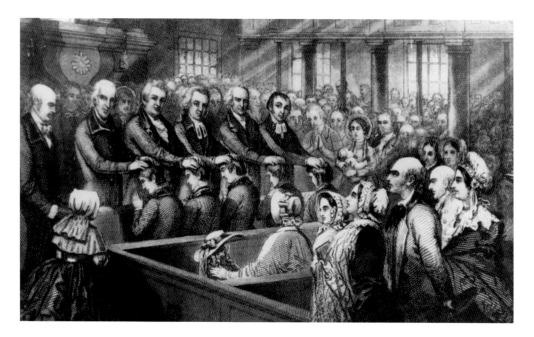

Ann Hasseltine Judson, Consecration, 1812
This image shows the consecration of the first five American missionaries to foreign lands. It took place at Tabernacle Church in Salem, Massachusetts, on the morning of February 6, 1812. The female figure in the bottom left-hand corner is said to portray Judson. The five set sail four days later. (Image courtesy of HPLSC.)

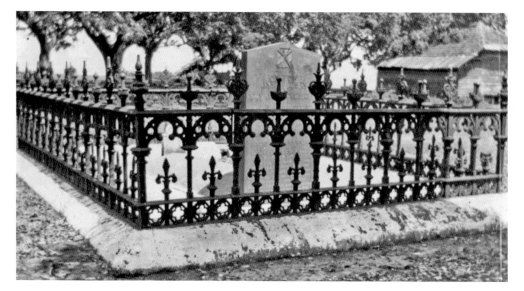

Grave of Ann Hasseltine Judson, Burma
Judson had three children, none of whom survived past infancy. Her first pregnancy ended in a miscarriage, and her son Roger died at eight months old. Judson died of smallpox on October 24, 1826, in Burma. Judson's third child, Maria, died six months after her mother. The thatch-roofed building to the right in this image is the Judson Baptist Church. (Image courtesy of HPLSC.)

David and Cordelia Gile, 66th Wedding Anniversary
David Gile (c. 1819–1913) built a home on Kenoza Avenue in 1856 and was well known for planting maple trees on Highland Avenue. In his will, Gile left his home and $1,000 to the Tuskegee Normal and Industrial Institute of Tuskegee. The will stated that if the property was not adequate for the home, the home would be sold and the money invested until there were proper funds for this purpose. (Image courtesy of HPLSC.)

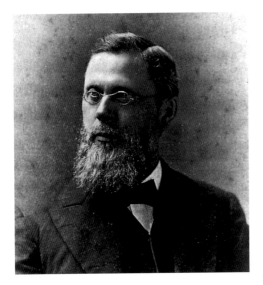

Isaac N. Carleton
Born in Bradford, Carleton (1832–1902) attended Phillips Academy in Andover, Massachusetts, before graduating from Dartmouth College in 1859. He later taught Latin and Greek at Phillips Academy and was principal of Peabody High School and several other New England secondary schools. Carleton founded and was principal of the Carleton School for Boys in Haverhill from 1884 to 1901. The building still stands at the corner of Chadwick Street and South Main Street in Bradford. (Public domain image.)

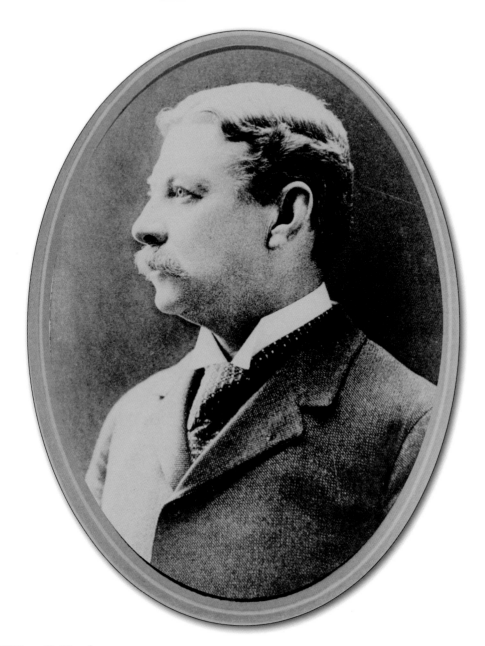

William H. Moody
Moody (1853–1917) was born in Newbury, Massachusetts, and was a graduate of Phillips Academy in Andover (1872) and Harvard University (1876), where he studied law, later establishing a law practice in Haverhill. He was one of the two prosecutors in the Lizzie Borden trial in 1892. Moody also held various political positions including city solicitor, district attorney, and congressman. In 1902, he resigned from the House of Representatives to become the secretary of the Navy. He later became attorney general of the United States under Pres. Theodore Roosevelt. In 1906 Roosevelt nominated Moody as associate justice of the Supreme Court of the United States. He held this post for four years. Moody School on Margin Street was named for him. He died in Haverhill and is buried in Georgetown, Massachusetts. (Image courtesy of HPLSC.)

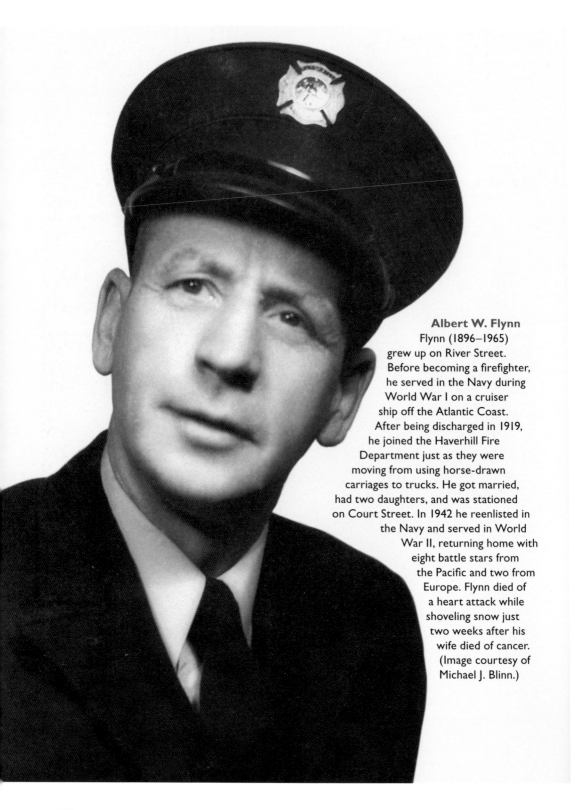

Albert W. Flynn
Flynn (1896–1965) grew up on River Street. Before becoming a firefighter, he served in the Navy during World War I on a cruiser ship off the Atlantic Coast. After being discharged in 1919, he joined the Haverhill Fire Department just as they were moving from using horse-drawn carriages to trucks. He got married, had two daughters, and was stationed on Court Street. In 1942 he reenlisted in the Navy and served in World War II, returning home with eight battle stars from the Pacific and two from Europe. Flynn died of a heart attack while shoveling snow just two weeks after his wife died of cancer. (Image courtesy of Michael J. Blinn.)

John C. Chase

New Hampshire–born Chase (1870–?) was elected mayor of Haverhill in 1898, the first Socialist mayor of a US city. He was reelected in 1899 and later became chairman of the Social Democratic Party at the national convention in 1901. He was a candidate for governor in both Massachusetts and New York, became state secretary of Nebraska, and was a candidate for Congress in West Virginia. (Image courtesy of HPLSC.)

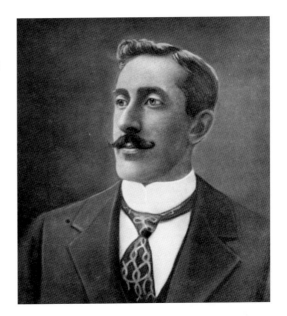

Funeral of Nora Minihan, St. James Church

Jeremiah Minihan (1903–1973), son of Nora, was born in Haverhill, where he graduated from St. James High School in 1921, earning a sports scholarship to Georgetown University. He went on to attend St. John's Seminary and was ordained as a priest in 1929 in Rome. His religious career included secretary to the Cardinal (1933), private chamberlain to Pope Pius XI (1936), monsignor and domestic prelate for Pope Pius XII (1937), pastor of several churches (1946–1972), regional bishop, and finally bishop (1954). When he died in 1973 on a trip to Ireland, he was the senior auxiliary bishop of the Boston Archdiocese. (Image courtesy of HPLSC.)

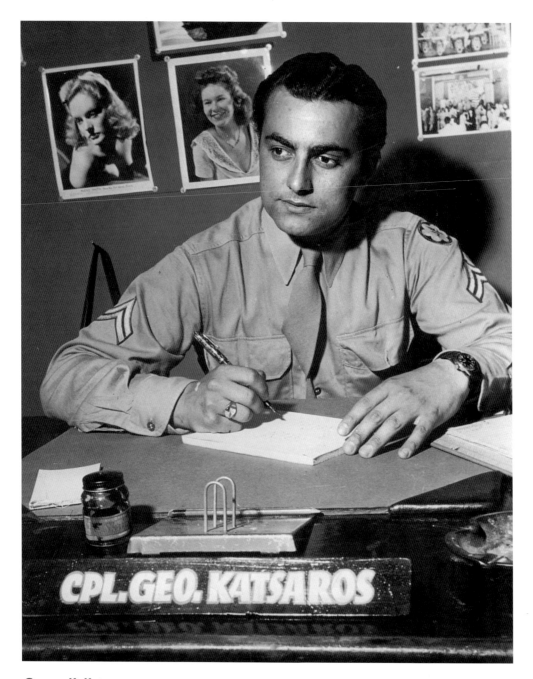

George K. Katsaros
Katsaros (1918–1982) attended Haverhill public schools before serving in World War II. While he was a sergeant at Camp Crowder in 1946, he became the bandleader and produced many variety shows for the military. After returning from the war he used his musical talents to entertain Haverhill as George Kay and his Orchestra. Katsaros later became a businessman, a sales representative, and was in public service as both a city councilor and mayor for three terms. (Image courtesy of Effie Katsaros.)

Bernard "Barney" Gallagher

Perhaps the most well-known newspaper reporter in Haverhill, Gallagher (1922–present) graduated from Haverhill High School in the illustrious class of 1939. He began his career in 1935 while still in high school as a correspondent with the *Sunday Record*, where his uncle was the editor. Two years later he moved to the *Gazette*, where he ultimately advanced up the ranks to managing editor. In 1942 he interrupted his career when he joined the US Army Air Corps as a photographer, serving in the Pacific. It was his work photographing the end of World War II that Gallagher has said is his proudest accomplishment. After returning from the war, he married and started a family before rejoining the staff of the *Haverhill Gazette* in 1946 as a reporter and photographer. In 1981 he joined the staff of the *Eagle Tribune* as a Haverhill reporter. Gallagher still writes the column "My Haverhill" for the *Tribune* and was a major contributor to the "Lamplighter" column in the *Gazette*. He has also been the recipient of numerous awards, including the Liberty Bell award in 1976, the Man of the Year by the Haverhill Chamber of Commerce in 1979, the Outstanding Alumni Award (HHS) in 1979, the B'nai B'rith Community Service award in 1980, and was inducted into the New England Press Association's Hall of Fame in 2003. Gallagher has also been very involved in the community. He served as co-chairman of the Haverhill Bicentennial Commission from 1975 to 1976; was chairman and vice chairman of the All America City Committee; was a member of the Community Events Commission; and was the Haverhill representative for the Merrimack Valley Tourist Council. (Image courtesy of Barney Gallagher.)

Karen McCarthy

McCarthy (1947–2010) was born in Haverhill and grew up in Kansas. She was an English teacher before running for public office. She was first elected to the Missouri House of Representatives in 1976, where she was reelected eight times, and in 1994 she became the first female president of the National Conference of State Legislatures. After leaving politics, McCarthy served on numerous boards and was active in fundraising for cultural and political activities. (Image courtesy of United States Congress.)

Gregory H. Laing

Laing (1947–2008) was born in Haverhill and was a graduate of Pentucket Regional High School in 1965, later attending Boston University. He became the curator of the Special Collections at the Haverhill Public Library, a job he held for 30 years. While in this position he helped countless people investigate their family histories and conduct other historical research. In 1981 he joined the library's board of directors, where he served for 26 years. Most of the town's history was stored in his head, earning him the nickname "talking encyclopedia." He was the leading authority on local architecture and gardening, especially hostas, which can still be seen around his dad's home in West Newbury. In 2007 the Haverhill City Council presented Laing with its first Historical Commission Preservation Award, mainly because of his work in archiving the city's history. The Haverhill Bar Association awarded him the 2007 Liberty Bell Award posthumously. (Image courtesy of Donald K. Laing.)

James G. Michitson

Michitson (1950–present) was born in Haverhill and was a graduate of Haverhill High School in 1968. He is a chemist/pretreatment coordinator at the Haverhill Wastewater Treatment Plant on South Porter Street. He began his career at the plant in 1977 when it opened, overseeing the laboratory and the industrial pretreatment program, implementing various policies along the way. Michitson started the Community Emergency Response Team, serving as emergency management director from 1998 to 2008. (Image courtesy of PTP.)

Dr. James E. Rothman

Rothman (1950–present) was born in Haverhill and studied at both Yale and Harvard before going on to become the Wallace Professor of Biomedical Sciences at Yale University in 2008. During his career he was a professor at other institutions such as Stanford University, Princeton University, and Columbia University. He is known as one of the world's most distinguished biochemists and cell biologists, specializing in membrane trafficking, which is the way proteins and other materials are transported within and between cells. (Image courtesy of Willa Bellamy.)

Haverhill Firefighters Arm Patch
This patch, which can be purchased at the Haverhill Firefighting Museum on Kenoza Avenue, includes the words "Suppression," "EMS," "Prevention," and "Rescue," important themes to the Haverhill Fire Department. Established in 2003, the museum contains numerous artifacts from the fire department's past, including antique trucks, rescue equipment, helmets, uniforms, and badges. There are photographs dating back to the 1800s, as well as videos of historic fires from the city's history. (Image courtesy of PTP.)

JUNE 1954. 1.WEST • 2.SMITH •3.KIMBALL• 4.CHESLEY • 5.BURNHARDT• 6.DAWKINS• 7.LONG • 8.WRIGHT • 9.LANGTON • 10.KNAPP • 11.BILIDEAU • 12.JORDAN •13.CANNEY • 14.HALL• 15.POITRAS • 16.MERIN • 17.HUBERDEAU 18.PERKINS • 19.ARCHIBALD •20.ROLLIE • 21.QUICKLY • 22.WEISCESHOOK • 23.NOYES • 24.MEEHAN • 25.SPEARS • 26.BORDEN •

Haverhill Firefighters Memorial Service, June 1954
Over the years the city of Haverhill and its firefighters have paid tribute to those men and woman who have put themselves in danger to protect the area's citizens. One of the greatest tests for these firefighters occurred on February 17, 1882, when fire broke out in Haverhill's shoe district. The fire did millions of dollars worth of damage and destroyed most of the factories on both sides of Washington Street and parts of Wingate Street. (Image courtesy of Haverhill Firefighting Museum.)

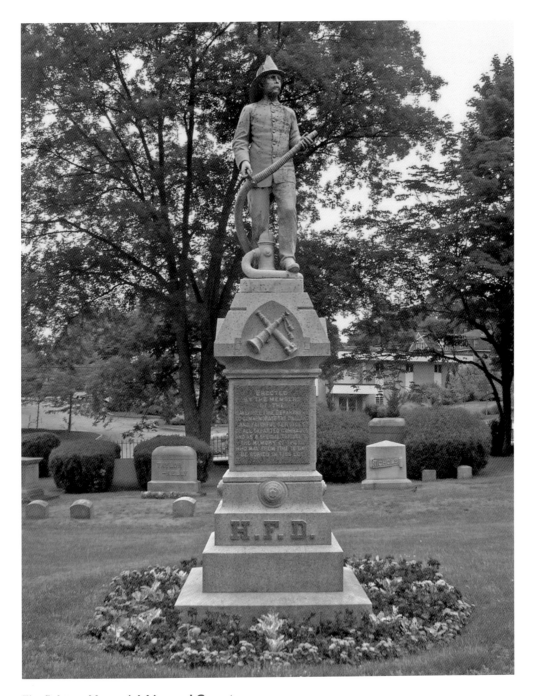

Firefighters Memorial, Linwood Cemetery
This six-foot-two-inch-tall statue is made of Italian statuary marble. It was designed by Weeks Cummings & Co. and was made in Carrara, Italy. It stands on a base of Rockport granite. The inscription on the front reads, "Erected by the members of the Haverhill Fire Department to commemorate the gallant and faithful service of all departed comrades, and as a special tribute to the memory of those who may from time to time be buried in this lot."(Image courtesy of PTP.)

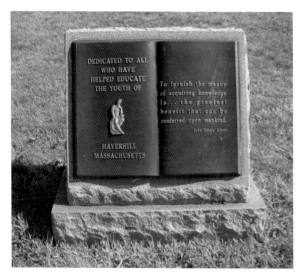

Haverhill Teachers Monument, City Hall
The Teachers Monument is located in front of city hall on Summer Street. It reads: "Dedicated to all who have helped educate the youth of Haverhill Massachusetts" and includes a quote from John Quincy Adams. Adams was a student of his uncle John Shaw, a Haverhill resident, for one year before entering college. Early education in Haverhill consisted of a man or woman teaching the children their lessons just a few hours per day. The first of these teachers was Thomas Wasse, who was appointed in 1660 and continued teaching until his death in 1673. (Image courtesy of PTP.)

Augustine J. Reusch Jr. at the Whittier Birthplace
"Gus" Reusch (1934–present) was born in Lawrence, Massachusetts, and later moved to Haverhill. He has been a teacher since 1965 at both St. Joseph's School and the public schools teaching history and literature. Throughout his teaching career he has instilled a love of history in his students and continues after his retirement to inspire students by volunteering in the schools, teaching Haverhill history. He also visits local nursing homes, where he brings in old photos to the senior citizens for them to reminisce about their past. Reusch is the curator at the Whittier Birthplace, where he gives guided tours of the grounds and sometimes dresses up like Whittier to reenact scenes of his life. (Image courtesy of PTP.)

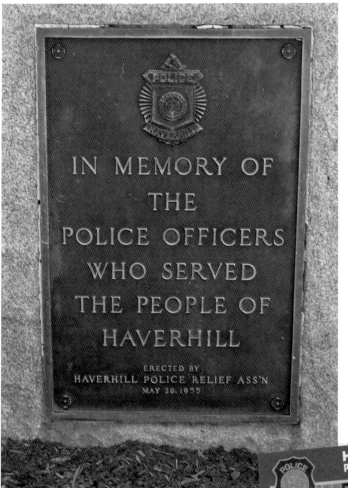

Haverhill Police Monument, Police Headquarters
A memorial dedicated to the police officers of Haverhill was erected in 1955 by the Haverhill Police Relief Association. It is located at the entrance to the police station on Ginty Boulevard, accompanied by three larger stones that list the names of deceased police officers beginning with the year 1956. (Image courtesy of PTP.)

Officer Osmond Hardy, Trading Card
"Ozzie" Hardy (1950–present) was born in Beverly, Massachusetts. He joined the Haverhill Police Department as a reserve officer in 1981, becoming full time in 1986. He was involved with the DARE Camp and ran the Junior Police program with the Exchange Club for more than 20 years. Since 1988 Hardy has organized Ozzie's Kids, a program that collects toys and clothes for needy children and distributes them at Christmas. (Image courtesy of Ozzie Hardy.)

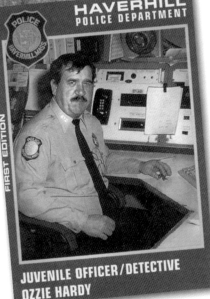

Haverhill Mayors, City Hall
This historic photograph of Haverhill's living mayors was taken on August 4, 2011 in Mayor Fiorentini's office at Haverhill City Hall. Pictured in the photograph (from left to right) are former mayors James F. Waldron (1968–1971), Lewis C. Burton (1976–1977), William H. Ryan (1982–1987), James A. Rurak (1994–2001), John J. Guerin Jr. (2002–2003) and James J. Fiorentini (2004–present). Missing from the photograph is Theodore A. Pelosi Jr. (1988–1993), who was unavailable. The mayors posed for this portrait specifically for this book and to pay homage to all of the citizens of Haverhill past and present. (Image courtesy of Linda Koutoulas.)

CHAPTER SEVEN

Military Service

Greater love has no one than this:
to lay down one's life for one's friends.
John 15:13

The city of Haverhill has sent many of its sons and daughters into harm's way. Haverhill citizens have fought in major wars, unnamed wars, and local skirmishes, as evidenced by the many cemeteries and burial grounds around Haverhill where the bodies of its soldiers and pioneers were laid to rest. Just look at the gravestones and you will see that many of these people died young. It does not matter what war was being fought—the American Revolution, Civil War, or one of the world wars—Haverhill citizens have volunteered by the thousands to do their duty, all of them risking their lives and their livelihood for the sake of the nation. The tragedy of today is that war still exists and lives are still being lost. People like Evan O'Neill, who died in Afghanistan in 2003, Dimitrios Gavriel, who died in Iraq in 2004, and Nicholas D. Schiavoni, who died in Iraq in 2005, gave the ultimate sacrifice. There are unfortunately too many names and stories to fit inside a book such as this, but we had to take the time to remember the hardships these people endured. The city of Haverhill has erected many monuments throughout town to honor these courageous souls. In addition to mentioning a few individuals, we have chosen to use these monuments and statues to serve as a testament to the bravery and patriotism to all who have served.

The Revolutionary War Memorial, GAR Park
This memorial is located in GAR Park (facing Winter Street) and was erected in 1915 by the Daughters of the American Revolution. On April 19, 1775, when the Battle at Lexington and Concord began, 105 men from Haverhill marched out to fight including James Brickett. Another one of Haverhill's Revolutionary War soldiers was Moses Hazen (1733–1802). He was a Revolutionary War general who was born in Haverhill and served at Brandywine and Germantown in 1777. He was later promoted to brigadier general and fought at the Battle of Yorktown. He is buried in New York. (Image courtesy of PTP.)

Gravestone of James Brickett, Pentucket Cemetery

Brickett (1738–1818) was born in Newbury, Massachusetts, and established a medical practice in Haverhill in 1762. His military career included being a surgeon's mate in the French and Indian War, becoming the first captain to lead the Haverhill Light Artillery Company, and then leading the 10th Massachusetts Volunteer Regiment at the Battle of Bunker Hill. Later, in 1776, he was named brigadier general, leading troops during a "sea battle" at Lake Champlain. After the surrender of British general John Burgoyne's troops at Saratoga in 1777, which was a turning point in the war, General Brickett led a march of about 6,000 prisoners from the Hudson River to Cambridge, a march of about 200 miles. He later served as a member of the Constitutional Convention in Boston in June of 1870. His home on Water Street was the scene of numerous reunions of his officers, and this house stayed in his family until it was sold to Israel Carleton in 1888. General Brickett is buried in Pentucket Cemetery, marked with a headstone put up by the DAR Chapter in 1996. (Image courtesy of PTP.)

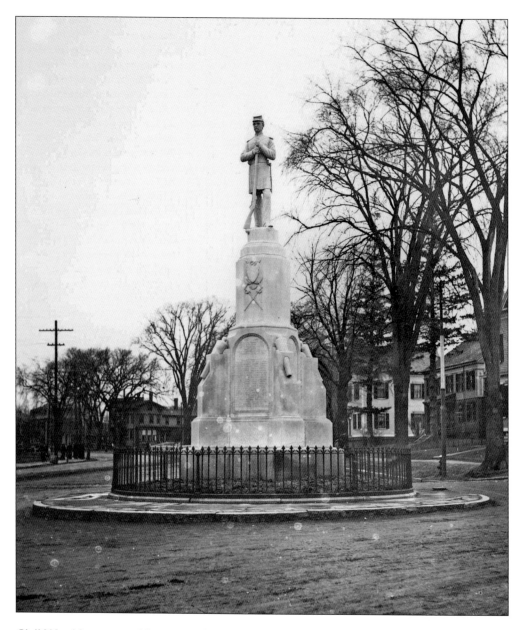

Civil War Monument, Monument Square
This monument, located at the intersection of Main Street and Kenoza Avenue, was dedicated in 1869. It is also known as the Soldiers Monument and was based on the likeness of William Francis Bartlett. It was the first public sculpture erected in Haverhill. Another memorial to Civil War veterans is Grand Army of the Republic (GAR) Park, which was dedicated to Major How Post 47 on May 30, 1925. Approximately 2,000 men from Haverhill served in the Civil War, including volunteer militiamen called the Hale Guards (which later became Company D), who drilled weekly and purchased their own uniforms (at a cost of $30 each), knapsacks, overcoats, and blankets. They were organized by Gen. Benjamin F. Butler on July 19, 1853. The first Haverhill soldier to die in the Civil War was Pvt. Hiram S. Collins. A Medal of Honor was awarded to Sgt. William H. Howe of Haverhill in 1895. (Image courtesy of HPLSC.)

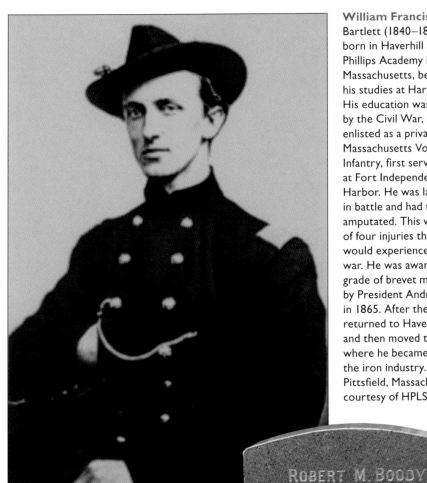

William Francis Bartlett
Bartlett (1840–1876) was born in Haverhill and attended Phillips Academy in Andover, Massachusetts, before beginning his studies at Harvard in 1858. His education was interrupted by the Civil War, and he enlisted as a private with the Massachusetts Volunteer Infantry, first serving his duties at Fort Independence in Boston Harbor. He was later wounded in battle and had to have his leg amputated. This was the first of four injuries that Bartlett would experience during the war. He was awarded the grade of brevet major general by President Andrew Johnson in 1865. After the war, he returned to Haverhill, married, and then moved to Virginia, where he became involved in the iron industry. He is buried in Pittsfield, Massachusetts. (Image courtesy of HPLSC.)

Gravestone of Robert M. Boody, Greenwood Cemetery
Boody (1838–1913) received the Congressional Medal of Honor for his service during the Civil War. While serving as a sergeant, and later a corporal, he saved wounded comrades from the battlefield at both Williamsburg and Chancellorsville. He is buried in Greenwood Cemetery in Haverhill. (Image courtesy of PTP.)

ROBERT M. BOODY
MAR. 8, 1838 — OCT. 22, 1913
CO. B. 40TH N.Y. VOL.
PRESENTED WITH MEDAL OF HONOR BY CONGRESS FOR BRAVERY
MARY W. HIS WIFE
AUG. 8, 1845 — MAR. 22, 1931
FRED W. BOODY
NOV. 27, 1869 — NOV. 16, 1930

BOODY

Spanish-American Cannon, GAR Park

Haverhill pays tribute to veterans of the Spanish-American War with two memorials. The first was a cannon used to defend the coast of Narragansett Bay, sent by the US government and placed in GAR Park on October 2, 1920. In 1975 a dump truck rolled down Main Street and crashed into the cannon, destroying it. For years the cannon sat undiscovered behind a barn on Main Street, eventually being restored years later. It currently sits in front of the Hannah Dustin statue in GAR Park. (Image courtesy of PTP.)

Spanish War Veterans Memorial, Gale Park

The second memorial to the Spanish-American War is the Spanish War Monument (also known as "The Hiker"), located in Gale Park on Kenoza Avenue. It was erected by the City of Haverhill and dedicated on October 24, 1926, to commemorate the valor and patriotism of the men of the Spanish-American War, the Philippine Insurrection, and the China Relief Expedition (1898–1902). (Image courtesy of HPLSC.)

John Mapes Adams

Adams (1871–1921) was born in Haverhill and attended Phillips Exeter Academy in Exeter, New Hampshire, before becoming a sergeant in the Marine Corps (under the alias George Lawrence Day). He received the Medal of Honor during the Boxer Rebellion in China in 1900 and is buried in New York. (Image courtesy of History Division US Marine Corps.)

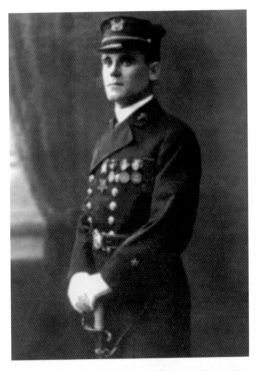

Spanish War Veterans Group Stone, Elmwood Cemetery

Many of the veterans of this war lie near a group stone in the Elmwood Cemetery that was dedicated on November 10, 2009. At the time of the dedication, the markers of the individual soldiers were cleaned and restored. Pvt. Charles C. Cook, whose grave is in an older section of the cemetery, was taken prisoner near Capas and later murdered on the orders of the commanding officer. Cook's gravestone reads in part, "Tell my father I die like a soldier." (Image courtesy of PTP.)

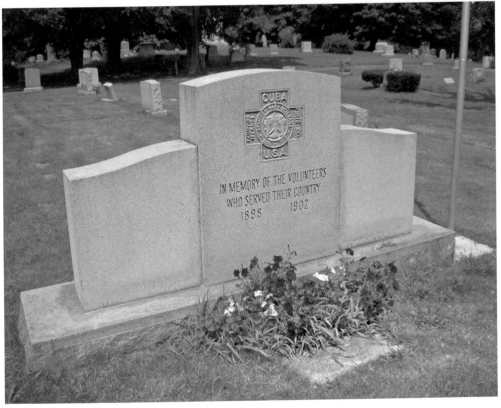

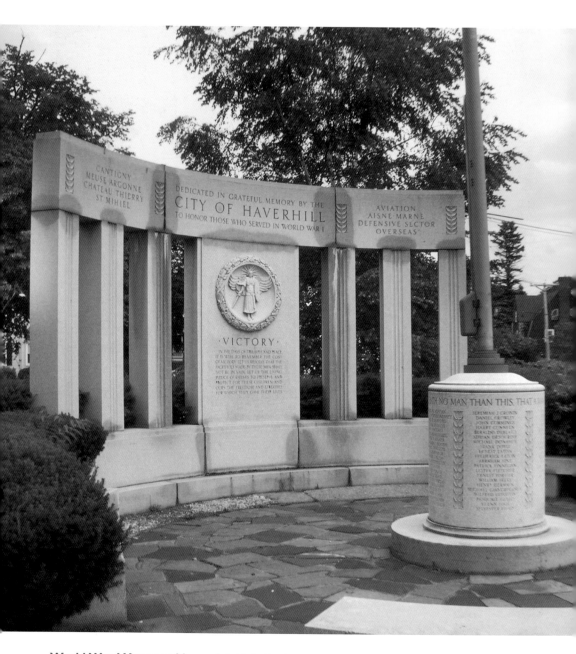

World War I Veterans Memorial, Gale Park

The City of Haverhill erected a large memorial to World War I veterans in Gale Park on Kenoza Avenue. It reads in part: "Dedicated in Grateful Memory by the City of Haverhill to Honor those who served in World War I." On stone pillars are the names of deceased veterans under the phrase "That a man lay down his life for his friends—Greater love hath no man than this." One of these men was Wilbur M. Comeau, the first Haverhill man killed in World War I (in France on April 12, 1918). (Image courtesy of PTP.)

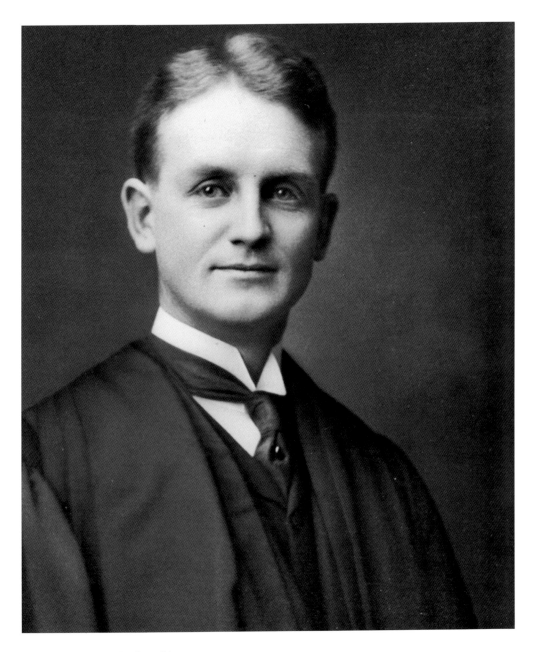

Reverend Henry A. Arnold
Arnold (?–1925) was the 13th minister of the First Church of Christ in Bradford. His pastorate began on September 15, 1914. He had just finished his studies at Yale Divinity School and arrived just as World War I was beginning. Although the thought of war was troubling, he still preached high ideals to his congregation: "The conditions surrounding the life of the church for the past 12 months have been indeed most abnormal. . . . Our very brains were saturated with the war; our sympathies were all entangled in the war; we have been so entirely engrossed in the mighty international issues of our day that it is little to be wondered if all other interests have suffered from neglect." Reverend Arnold left in 1919 to become pastor of a church in Ohio. (Image courtesy of First Church of Christ.)

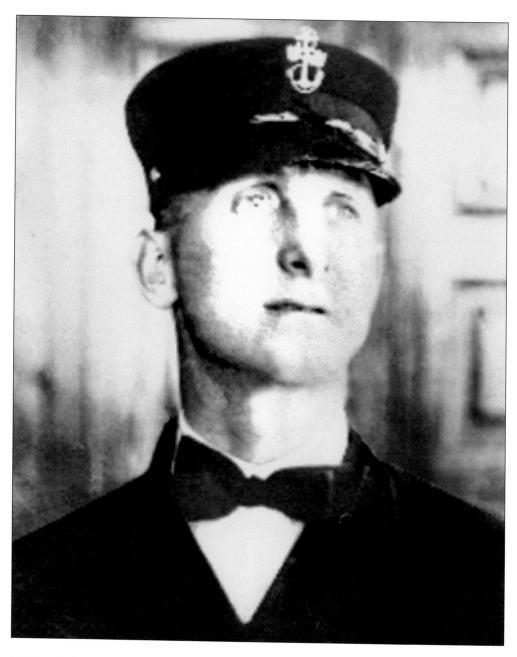

William J. Sharkey

Born in New York, Sharkey (1885–1918) was a Haverhill resident who served as an officer in the Navy during World War I, assigned to submarine service. He was killed while heroically trying to prevent an explosion on the submarine USS 0-5 in 1918. He was later posthumously awarded the Navy Cross and the USS *Sharkey* (DD-281), a Clemson-class destroyer, was named in honor of him on August 12, 1919. The ship was commissioned on November 28, 1919, and remained in service until it was decommissioned on May 1, 1930. (Image courtesy of Charles R. Hinman, Director of Education and Outreach, USS *Bowfin* Submarine Museum and Park.)

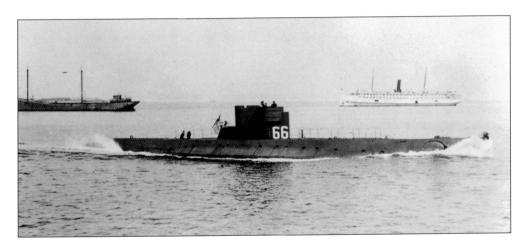

USS 0-5 (SS-66), O-class Submarine
This submarine was laid down by the Four River Shipbuilding Company in Quincy, Massachusetts, on December 8, 1916. She was launched on November 11, 1917, under the command of Lt. George A. Trever. Trever and two crewmen, William Sharkey and J.L. Stills, were killed on October 5, 1918, in a battery explosion. The submarine later sank on October 28, 1923, after a collision with the SS *Abangarez*. (Image courtesy of Charles R. Hinman, Director of Education and Outreach, USS *Bowfin* Submarine Museum and Park.)

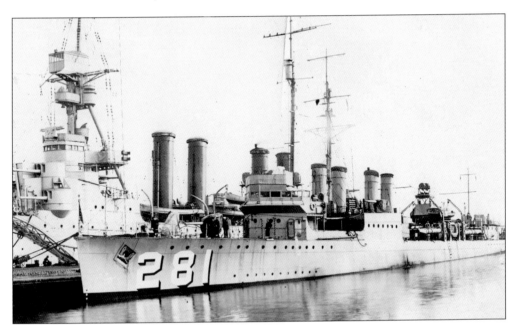

USS *Sharkey* (DD-281), Clemson-class Destroyer
Laid down by the Bethlehem Shipbuilding Corporation in Squantum, Massachusetts, USS *Sharkey* was launched on August 12, 1919. The ship spent most of her life serving in the Atlantic Ocean with brief stints in the Pacific Ocean and Mediterranean Sea. In July of 1929 she was scheduled for overhaul when instead she was ordered to be decommissioned in 1930 and was sold as scrap in 1931. (Image courtesy of HPLSC.)

121

Walter Newell Hill

Hill (1881–1955) was born in Haverhill and attended Harvard University (1904). He became a second lieutenant in the Marines in 1904 and served actively until 1938, later coming out of retirement to serve in World War II at Marine Corps Headquarters in Washington, DC. He was awarded the Medal of Honor for bravery during the capture of Vera Cruz, Mexico, in 1914. General Hill advanced through the military, becoming a brigadier general in 1938 before he retired in 1945 after a 40-year career. He died in New York and is buried at Arlington National Cemetery. (Image courtesy of Arlington National Cemetery Website.)

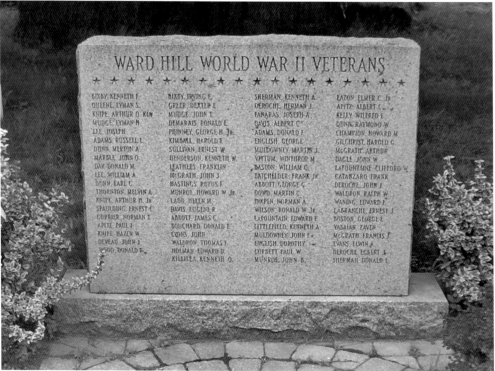

World War II Veterans Memorial, Ward Hill

The only memorial in Haverhill solely devoted to the veterans of World War II is in Ward Hill, at the corner of Main Street and Ferry Road. It lists the names of Ward Hill veterans. However, the city of Haverhill did publish a book, *Haverhill in World War II*, a copy of which was distributed to all city veterans, or their survivors, honoring the men of this war. This was a huge undertaking, considering the book was 763 pages long and there were 6,700 copies printed. It was dedicated "to the men of Haverhill who died that their country might live." These include men such as Gaylord H. Whitney, the first Haverhill man to die in World War II. He was lost at sea on February 18, 1942, when his ship, the USS *Houston*, was sunk by a Japanese submarine. (Image courtesy of PTP.)

John Katsaros

Katsaros (1923–present) graduated from Haverhill High School in 1942. He served in the United States Air Corps, where he trained as an aircraft engineer/aerial gunner. He became a crew member on the B-17 Flying Fortress Heavy Bomber and participated in bombing targets over Germany. During a 1944 battle over Frankfurt, Germany, his aircraft was seriously damaged and the crew had to bail out. Katsaros was injured and then taken as a prisoner by the Gestapo two different times. He escaped with help from the Free French Resistance and was assisted to Spain, where again he was imprisoned by the Spanish Constabulary. Upon his return to America, he went on to graduate from Boston University, became president of several banking, finance, and real estate firms, and wrote a book called *Code Burgundy—The Long Escape*, a recounting of his war experiences. He was also named "Chevalier" of the Legion of Honor by Pierre Vimont, French Ambassador to the United States, in 2010. (Image courtesy of John Katsaros.)

Korean War Memorial, GAR Park

This memorial in GAR Park was dedicated on November 30, 2002, and is near the corner of Winter Street and Welcome Street. It consists of a bronze soldier statue, numerous flags, and a commemorative brick walkway. Over 800 men and women from Haverhill served in the Korean War, including 16 who lost their lives. The first of these was Corporal Edward F. O'Neil, who served in the Army in the Pacific Theater from 1943 to 1945, then reenlisted in 1948 and was sent to Korea, where he was killed in action on July 16, 1950. (Image courtesy of PTP.)

Vietnam Veterans Memorial, Water Street

This memorial is located at the corner of Main Street and Water Street on the Haverhill side of the Basiliere Bridge. Made up of a metal sign and a stone monument with a bronze plaque, it was dedicated on April 29, 1973. The bridge, formerly the Main Street Bridge, was renamed the Basiliere Bridge after Private First Class Ralph Basiliere. He was Haverhill's first casualty of the Vietnam War and died on May 17, 1966, from wounds suffered during a battle near Da Nang. Twelve other Haverhill men were also killed during this war. (Image courtesy of PTP.)

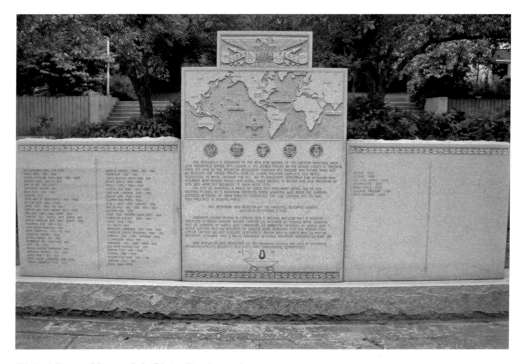

Global Peace Memorial, Ginty Boulevard
Located at the corner of Main Street and Ginty Boulevard in front of the Haverhill Public Library, this memorial was designed by the Haverhill Veterans Council and dedicated on September 2, 1995. It was erected to remember all of the members of the armed forces from the American Revolution to the present who helped bring peace to the world, whether they were missing in action, prisoners of war, or deceased. It was sponsored by the Veterans Council, the City of Haverhill, its residents, merchants, and surrounding communities. (Image courtesy of PTP.)

Women Veterans Memorial, Gale Park
This memorial in Gale Park facing Kenoza Avenue was dedicated by the Haverhill Veterans Council on September 26, 1999. It contains an etching of a woman in uniform, five military seals (Army, Navy, Air Force, Marines, and Coast Guard), and a gold lamp lit with three flames. It honors the women who have served or are serving in all branches of the US Armed Forces. (Image courtesy of PTP.)

BIBLIOGRAPHY

Chase, George Wingate, *The History of Haverhill, Massachusetts*. Camden, ME: Picton Press, 1997.

Cogswell, Hon. John B. D., *Haverhill, 1640–1888*. Philadelphia, PA: J. W. Lewis & Co., 1888.

Freeman, Donald C., *The Story of Winnekenni, 1640–1976*. Haverhill, MA: The Board of Directors of the Winnekenni Foundation, 1977.

Freeman, Donald C., John B. Pickard and Roland H. Woodwell, *Whittier and Whittierland*. Haverhill, MA: HPL Press, 1976.

Frothingham, E. G., *A Ramble About Haverhill in My Boyhood Days*. A paper read before the Haverhill Historical Society, 1921.

Gage, Mary Elaine and James E. Gage, *Stories Carved in Stone*. Amesbury, MA: Powwow River Books, 2003.

Kingsbury, J. D., *Memorial History of Bradford, Mass*. Haverhill, MA: C. C. Morse & Son, 1882.

O'Malley, Patricia Trainor, *Images of America, Bradford, the End of an Era*. Dover, NH: Arcadia Publishing, 1996.

O'Malley, Patricia Trainor, *Images of America, Haverhill, Massachusetts From Town to City*. Dover, NH: Arcadia Publishing, 1997.

O'Malley, Patricia Trainor, *Images of America, Italians in Haverhill*. Charleston, SC: Arcadia Publishing, 2001.

O'Malley, Patricia Trainor, *Images of America, The Irish in Haverhill*. Dover, NH: Arcadia Publishing, 1998.

O'Malley, Patricia Trainor, *Images of America, The Irish in Haverhill Volume II*. Charleston, SC: Arcadia Publishing, 1999.

O'Malley, Patricia Trainor and Paul H. Tedesco, *A New England City: Haverhill, Massachusetts*. Northridge, CA: Windsor Publications, Inc., 1987.

Pupils of the eighth grade, *A City Grows, The Story of Haverhill, Mass*. Haverhill, MA: The Printing Department of the Charles W. Arnold Trade School, 1949.

Tedesco, Paul H., *Haverhill Celebrates Haverhill's 350th, 1640–1990*. Haverhill, MA: HPL Press, 1990.

Thayer, Maud Palmer, *The Beginnings of Bradford*. Haverhill, MA: Record Publishing Company, 1928.

Turner, Charles W., *Remembering Haverhill, Stories from the Merrimack Valley*. Charleston, SC: The History Press, 2008.

INDEX

Abbott, Ira A., 23
Adams, John Mapes, 117
Alter, Louis, 56
Appleton, Daniel, 72
Arnold, Henry A., 119
Ashworth, Gerald, 65
Atwood, Donald J., 87
Ayer brothers, 80
Ayer, Lydia, 21
Bacon, Henry, 42
Bailey, Thomas H., 79
The Barefoot Boy, 21
Bartlett, Bailey, 14
Bartlett, William Francis, 115
Bell, Alexander Graham, 71, 77
Bellairs, John A., 27, 29
Bergeron, Tom, 68
Boody, Robert M., 115
Boot and Shoe City Sign, 81
Bowley, Edwin, 19
Brickett, James, 113
Breck, Peter, 61
Carleton, Isaac N., 98
Carleton, Walter Tenney, 78
Chase, Cora, 54, 55
Chase, George Wingate, 4, 11, 22, 27
Chase, John C., 101
Chase, Stuart, 22
Chase, Sydney Marsh, 43
Civil War, 20, 114
Cline, Maggie, 53, 54
Coco, Tim, 26
Cook, Gladys Emerson, 45
Crockett, James Underwood, 30
Crouse, David, 38
Dinan, Jeremy and Gerard, 89
Draper, Muriel Sanders, 25
Dubus, Andre II, 27, 34, 35
Dubus, Andre III, 27, 34, 35
Dustin, Hannah, 9, 11, 13, 73
Emiro, Pasquale, 27, 31
Fellows, Billy, 64, 65
Fitts, Dudley Eaton, 27, 28
Flynn, Albert W., 100

Fontaine, Frank, 57
Gallagher, Bernard, 4, 102, 103
Gile, David, 98
Golden, Christopher, 10, 27, 39
Goudsward, Scott, 27, 40
Gould, Michael, 49
Greenleaf, Benjamin, 16, 27
Hale, Ezekiel J.M., 73
Hamel, Louis H., 85
Hardy, Osmond, 110
Haseltine, George, 78
Hasseltine, Abigail Carleton, 95
Haverhill firefighters, 106, 107
Haverhill mayors, 93, 110
Haverhill police, 109
Haverhill teachers, 108
Hayden, Mark, 48, 49
Hayes, Kevin Paul, 69
Hill, Walter Newell, 122
Hunking, Caleb Duston, 72, 76
Hunkins Shoe Shop, 80
Janvrin, Harold Chandler, 54
Judson, Ann Hasseltine, 17, 96, 97
Katsaros, George K., 102
Katsaros, John, 123
Kimball Tavern, 10, 15, 71, 92
Kingsbury, John D., 4, 10, 11, 24, 27
Lahey, Frank Howard, 71, 83
Laing, Gregory, 4, 104
Lane, Patrick J., 90
LaPierre, Stephen, 50
Leonardi, Rick, 48
Levitan, Israel, 41, 46, 47
Livingston, Harold, 27, 32, 33
MacDougall, Duncan, 24
Macy, Rowland H., 71, 72, 76
Mayer, Louis B., 71, 84
McCarthy, Karen, 102
McIlveen, John M., 10, 27, 37
Merrill, Bruce, 86
Michitson, James G., 105
Migliori, Boris, 86
Minihan, Jeremiah, 101
Montana, Bob, 41, 44

Moody, William H., 99
Moutafis, Greg, 49
Mullicken, Robert Sr., 10, 14
Newell, Harriet Atwood, 17
Nichols, George P., 82, 83
Nichols, James R., 74, 75
O'Leary, Glenn, 92
O'Malley, Patricia Trainor, 4, 36
Parker, James and Cindy, 91
Peña, Carlos, 70
Pentucket Deed, 12
Reusch, Augustine J. Jr., 108
Rolfe, Benjamin, 9, 15
Rothman, James E., 105
Ruocco, Francesco, 41, 45
Ruskin, Joseph, 60, 61
Ryan, Michael J., 65
Sanders, Thomas S., 77
Saltonstall, Nathaniel, 94
Sapienza, Anthony, 62, 63
Scott, Winfield Townley, 27, 31
Shain, Jonathan, 69
Sharkey, William J., 120, 121
Silva, Oliver Wendell, 58, 59
Smiley, James Varnum, 18
Smith, Kendall C., 88
Smyth, Richard, 10, 27, 38
Smythe, Daniel Webster, 27, 29
Spider One, 66, 70
Strong, Charles Augustus, 29
Swasey, Helen "Gert", 52, 53
Thurston, Nathaniel, 10, 16
Whittier, John Greenleaf, 2, 4, 7, 11, 20, 21, 27, 108
Wood, Craig and Ryan, 92
Zombie, Rob, 66, 67, 70

AN IMPRINT OF ARCADIA PUBLISHING

Find more books like this at
www.legendarylocals.com

Discover more local and regional history books at
www.arcadiapublishing.com